HOWARD S. STERN

A LIFETIME
LOOKING

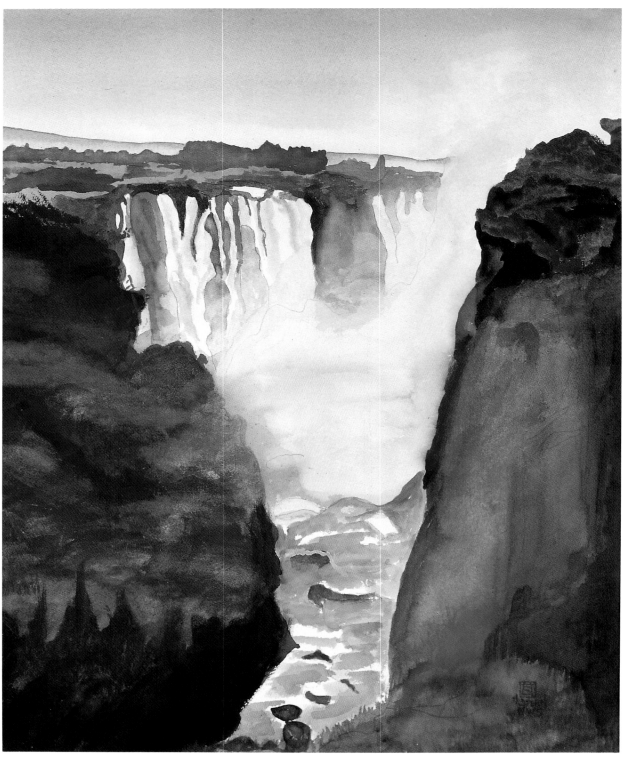

Victoria Falls (1988)
watercolor on paper, 30 x 22 inches

Photograph by Cindy Momchilov

HOWARD S. STERN
A LIFETIME LOOKING

With George West

Ellen C. Stern: Project Director / Editor

August House Publishers
LITTLE ROCK

Published by August House, Inc.,
P.O.Box 3223, Little Rock, Arkansas, 72203

Printed in the United States of America

10 9 8 7 6 5 4 3 2 1

LIBRARY OF CONGRESS CATALOGING-IN-PUBLICATION DATA

Stern, Howard S., 1910-
A Lifetime Looking / Howard S. Stern with George West:
Ellen C. Stern, project director, editor
- 1st ed.
p. cm.
Summary:
ISBN 0-87483-393-0 (PB): $20.00
ISBN 0-87483-392-2 (HB): 40.00
1. Stern, Howard S., 1910- —Catalogs. 2. Stern, Howard S., 1910 —Interviews
I. West, George. II. Stern, Ellen C. III. Title
N6537.S732A4 1994 94-35386
709'.2—dc20 CIP

First Edition, 1994

Executive editor: Ted Parkhurst
Project director/editor: Ellen C. Stern
Design: George West / Jan Diemer
Cover design: Wendell E. Hall

This book is printed on archival-quality paper that meets the
guidelines for performance and durability of the Committee on
Production Guidelines for Book Longevity of the
Council on Library Resources.

AUGUST HOUSE, INC. PUBLISHERS LITTLE ROCK

Front Cover: Untitled (1952)
Watercolor on paper, 12 x 9 inches
Photograph by Cindy Momchilov

PREFACE

In addition to her own agenda, Eleanor Freed Stern applied her resources to empower others. She contributed to the support of individuals struggling to produce art, to ameliorate social ills, to make sense of difficult lives. She was a friend and counselor, openhearted, plain-spoken, critical, humorous, discrete. A steadfast liberal, Eleanor was a proponent and supporter of progressive causes.

As a writer she gave exposure and thus power to art and artists.

Her underwriting of the 1992 exhibition catalog of Howard Seymour Stern's photographs and now, through her Foundation, the publication of his paintings and various work provides him a robust exposure.

The editorial task has been to convey the ebb and flow of Howard's attention, inward and outward, of his occluding self-consciousness and his precognitive ebullience, the latter to my mind having engendered his best art work. Interviews with him and his associates provide primary data for evaluating his preoccupation with winning—being loved, that is—which both inhibits and propels him.

The task of choosing and grouping the illustrations is to correlate the work over time, to seek consistencies, to attempt to unveil sublime patterns as all might hope, at some level, to be generating with our lives. Howard speaks little of these matters, so we are left with our observations.

As the center of attention, Howard's task is to remain honest with himself and his work and to control his pride, his excitement at being published and his fear that, with the completion of this book, he may come to believe he has met his highest goal and must now die. But I think he will go right on.

Arthur M. Stern

ACKNOWLEDGMENTS

The opportunity to produce a book about one's parent is rare. The collaboration of numerous people and organizations made it possible. Special thanks to: The Eleanor and Frank Freed Foundation in Houston, Texas, for commissioning the book and funding it through the Arts and Science Center for Southeast Arkansas in Pine Bluff; the Arts & Science Center for sponsoring the project and for lending works of art from its permanent collection; Townsend Wolfe for his thoughtful Introduction; The Arkansas Arts Center Foundation for lending a work from its collections; my brother Arthur for his down-to-earth editorial advice and for his Preface; Cindy Momchilov of Camera Work, Inc. in Little Rock, for her photographs and her technical advice on several points; Libby Lyon for her help in preparing the paintings to be photographed; and Ted Parkhurst and Jan Diemer of August House for being available, for advising me and, more often than not, for letting me have my way.

No amount of acknowledgment is sufficient to thank Daddy's friends and cohorts for contributing their recollections and their perceptive comments. Without their words this book would never have been so lively.

Working with George West—my old friend, Daddy's new one—was extraordinary. His knowledge and his insight, his patience with both Daddy and me, his genuine delight with the project, and his vision of the final form of the book were invaluable.

The project has been a remarkable experience for me. So many of the facts about my father's life and the stimuli that motivate him have been revelations, and I've come to understand him—and through him, myself—in many new ways.

Ellen C. Stern

ILLUSTRATIONS

ILLUSTRATIONS, CONTINUED

FOREWORD

The usual formula for a book about an artist is a formal biography or a critical analysis of the art work plus a collection of illustrations. This book is different. It is an oral history—a personal account of the art of Howard Stern, told through excerpts from taped conversations with him and other people from different times and places in his life.

The goal of this approach is to show Howard's works of art in a larger dimension—as part of the personal events and relationships in his life and also in terms of the styles and moods of changing times. To comprehend a work of art it is important to have some knowledge of the time in which it was created. That span of time in Howard's case ranges over almost seven decades and includes several diverse media. His art cannot be fully perceived just by looking at examples of his paintings or his photographs. Rather, it is through his personal life stories that the extent of his creative drive and artistic expression can be understood more completely.

What was Howard Stern looking at and what was he looking for, in photography and painting and rifle making? What prompted the movement from camera to brush to lathe to brush and camera again? How did he combine serious art with a profession as serious as surgery? What influence does a career as a surgeon have on his art and craft and vise versa? From what sources has new creativity come when periods of burnout set in? Who and what have been his teachers? And where to next as an artist? The answers to these and other questions are sought in the conversations that follow.

In one discussion about photography, Howard says that he does not try to make a statement about the subjects he chooses. He tries instead to let the subject speak for itself. By definition, that is also the aim of oral history and of this book.

George West

Since returning to his home state in 1978, GEORGE WEST has directed numerous oral history projects, ranging from family history to corporate history, regional folklore, and personal life narratives. He produced a series of documentary albums of authentic Ozark folktales and folksongs, two of which have been honored by the Library of Congress. His video documentaries on education in Arkansas, and on Arkansas folk arts, have aired on KTHV-Channel 11 and on the Arkansas Educational Television Network (AETN). West's work has been supported by grants from the Arkansas Arts Council, the Arkansas Endowment for the Humanities, the Winthrop Rockefeller Foundation, and the National Endowment for the Arts.

INTRODUCTION

Howard Stern has sought out domains as varied and seemingly as unrelated as music, stamps, target shooting, rifle making, nature, art collecting, talking, painting, photography and medicine. These areas have engaged his soul and being for over seventy years. In each of his chosen endeavors he has excelled. He has made sick people well, won prizes and championships, and he has been honored for achievements with membership in international societies. Because of his far-reaching efforts and successes, he has had and has given a lot of joy. His life is a variation on a theme of challenge and conquest of what he found around the bend.

Howard's son Arthur says, "Dad took on the world—that was his domain." And take it on is what he did. One of his first explorations occurred at the age of six when he read of the new dinosaur discoveries in a 1916 issue of National Geographic. This piqued his curiosity and challenged him to know all he could about them. He learned to draw every type of known dinosaur in detail from memory. His passion for investigation and comprehension has never ceased, nor has his commitment to knowledge and application. This early fascination with dinosaurs, coupled with his medical education, was of help years later in 1984 at Petrified Forest National Park when he identified a skull fragment from a Triassic reptile. The foundation of his life is studying and learning wherever the windows of his mind lead him.

Perhaps the only thing Howard Stern has yet to master is the concept that the shortest distance between two points is a straight path. He sees each curve and turn as an encounter, as a necessary route to take in his quest for life. At first glance he seems to go with the wind without purpose. He would be called a dilettante who flits superficially from one passing interest or whim to another, except for the fact that he does nothing superficially. He faces every curve and turn as an opportunity to be explored and conquered. To greet and then to master new challenges is Howard's life blood.

The challenge of the visual arts have continued for Howard from the 1920's through today with awards, exhibitions, catalogues and international recognition. The drive to make art stems from what he sees around him and the feelings he wishes to communicate. He is comfortable and sure with both photography and painting as means to express the importance of what he sees. His technical skills are never seen as the end product but rather only as a vehicle to this end.

His vision is one of organization and clarity of forms—the visual poetry of order. In all of his works, placement of forms is paramount. His compositional structure focuses our attention and orchestrates movement through the picture plane. He uses mass and contrast of size and tone to build interest.

For example, in his first watercolor (*Grain Elevator*, 1930), a flat, large white building dominates the space as it contrasts with the sky and the warmer, darker complex foreground. In *Sweet Repose* (1935), a photograph from the same time period, we see the dominant figure and tree contrasting in texture with the vegetation and the shadowy wall. In both works he employs a V-shape to create the illusion of space. He uses lines, shapes, textures and shadows from time to time to suggest spacial movement in the photographs and the paintings. His art progressed through the years with an underlying sense of continuity from pictorial composition to abstract images, and in more recent years, to super realism. In all of the works, structure, space, and clarity give strength to his visual message.

Howard's humanity flowers in his photographs and paintings. The works are of one eye and sensibility. They represent the man, Howard Stern, who is a spirit without constraint.

Townsend Wolfe

TOWNSEND WOLFE is Director and Chief Curator of the Arkansas Arts Center in Little Rock. He has served on councils and committees of the Association of Art Museum Directors, the American Association of Museums, the National Endowment for the Arts, the Institute of Museum Services, and numerous others.

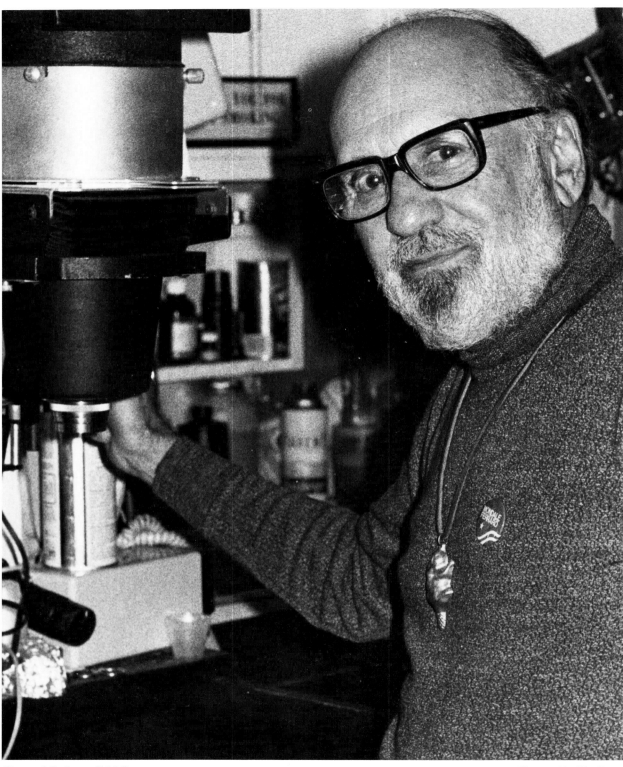

Howard S. Stern (1985)

Photograph by Kim Cherry
Courtesy of Department of Arkansas Heritage

A Conversation with Howard Stern and Thomas Harding: February, 1994

GEORGE WEST (INTERVIEWER): When did the two of you cross paths?

THOMAS HARDING (A RETIRED PROFESSIONAL PHOTOGRAPHER): What, two centuries ago?

HOWARD STERN: Yeah, about 1920. We lived in the same neighborhood. We used to kill Indians on the same lot.

TH: Right.

HS: It was back of the Franklin house.

TH: Yeah, back of George and Howard Franklin's. Sure was. Well, I'm going to leave now and let you two settle down.

GW: [TO TOM] Before you go, talk to me about how you two got connected artistically, apart from the Indian wars.

HS: I lived down on Broadway near Nineteenth, you know, and he lived on Twenty-fifth & Broadway. Then later, in the '30's, we got together in the Camera Club, didn't we?

TH: Right. We took pictures together. I never did get to go out painting with you all, but that was alright.

HS: That was the Ars Medica Tobacco Road Club.

TH: But then, I don't know, what, ten or twelve years ago, we ran into each other down at the Art Center and got to talking about New Mexico. Remember that?

HS: Yeah, and the next thing you know...

TH: ...we were on our way....

HS: And we had my camper trailer and so....

TH: Oh, that was a great trip.

HS: We've had several great trips.

GW: What equipment did you take?

TH: I'll tell you, he'd take everything. Half of the stuff in this house would go. It's unbelievable! He wouldn't use, what, one percent of what he took?

HS: Wasn't that the first trip—in 1984? Because that's when I bought that damn big graphic view camera.

TH: That was ridiculous! You admit it.

HS: Yeah, well, that was the only 4x5 I knew of at the time, and it was dirt cheap. I sold it for about twenty-five percent more than I paid for it.

TH: Howard, you don't have to make a profit on everything. For heaven's sake.

HS: But anyway, we made about three trips out there.One time we went up around the Four Corners area and back around near Mexican Hat and down through the Valley of the Gods and into Monument Valley. We spent a whole day there with a Navajo family. It was very interesting. We hired a guide who took us in there.

TH: No, he TOOK us.

HS: Yeah, he took us, for about eighty bucks apiece!

TH: Ridiculous! But it was enjoyable.

HS: Well, we learned how to make fry bread.

GW: What kinds of images were you looking for?

TH: You find yourself looking at the giant magma pipes as well as the tiny lichens...

HS: ...desert plants, whatever made a good composition, had good values, we'd shoot.

GW: Would you go out and walk together or split up and meet again later?

HS: We'd go together.

TH: We take it easy, don't we?

HS: Well, we're old enough that we can't be like we used to be.

TH: Yeah, like climbing barbed wire fences and that sort of thing.

HS: A young man—he can walk twenty miles to get a picture.

TH: Yeah, but we can't.

GW: When you'd both shoot the same subject, would you get similar negatives?

HS: We often take different pictures of the same subject. It's impossible for two guys to get the same picture.

TH: Right.

HS: No two people think the same way.

TH: Hey, just for the fun of it, let's pick one subject. I'll do it with the pinhole, and you [TO HOWARD] do it with one of your cameras and let's see what comes out. We've never tried that.

HS: OK. That would be an interesting experiment.

GW: I would find it very exciting to have a photography buddy to go out with and get ideas going.

TH: I don't know what I'd do without this guy. I really don't.

HS: Well, the same goes here.

TH: We just have a good time, that's all. We may not come back with great masterpieces in photographs, but....

HS: Sometimes I'll come back and I haven't burnt up any film, haven't snapped a picture.

TH: Haven't taken the cameras out of the car.

HS: But it was fun.

GW: When you're shooting new pictures, do you find yourself recalling similar images that you've shot in the past?

TH: Not really.

HS: Every picture is a whole new ball game.

TH: Sure is.

HS: But now and then, if a scene looks too much like one we've done before, we pass it up. There's no point in repeating. We're talking about going out sometime this week if the weather is clear. We'll try to get out as early as we can to catch the off-light.

TH: If we could see a stream with a nice waterfall, that might have some appeal, particularly if it had a grist mill that was a hundred years old standing by it. That would be good.

HS: Dream on.

TH: Dream on, right.

TH: If we found some sort of an unusual shape in an Arkansas hillbilly house, why, that would be good.

HS: An old tumbled down shack....

TH: Yeah.

HS: ...nice tree arrangements. Early as we can to catch the off-light.

TH: If it's good enough, you do the overall thing. Then you move in and do the details, you see?

GW: That's your way of netting a subject?

TH: Right.

HS: Well, usually part of it's not worth taking and you've wasted negatives, but then there's one little jewel that pops up occasionally.

TH: Yeah.

GW: What makes it a jewel?

TH: You answer that one, Howard.

HS: The way it grabs you when you look at it.

GW: That's the advantage of seeing new things, I guess.

HS: Sure.

TH: Because you're not contaminated with referring, like you were talking about, to something else.

HS: It's like any other medium. When you're writing you're not thinking of your pencil or your typewriter. When you're painting you're not thinking of your paper or brushes. You're thinking of what you're doing. It's the same way with photography. What you want to do is put that subject onto the paper. You put it on there the way you see it.

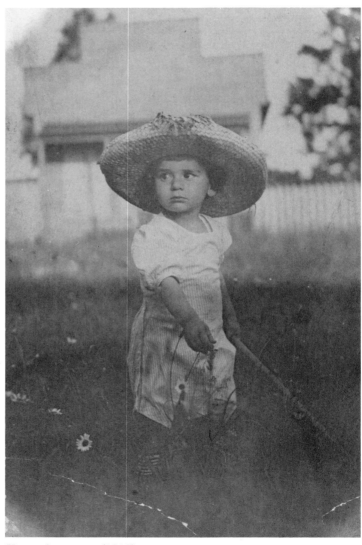

Howard, age two (1912)

Childhood Recollections: 1910 - 1928

Howard Seymour Stern was the eldest of four children and the only son of Eugene John Stern and Frances Burger Stern. In 1913 Gene Stern moved his family from North Carolina to Little Rock, Arkansas, to work with architect George R. Mann on the Arkansas State Capitol building.

HS: I was born in 1910. We were living in Charlotte, North Carolina. The first memory I have that comes pretty vividly at this time is my mama taking me out to the fence in our backyard when I was two years old and showing me morning glories, which were quite beautiful flowers. She explained to me that they were pretty flowers and that their names were morning glory. You know, I've never forgotten that.

Another memory I have of Charlotte—we were near Kitty Hawk—was seeing the airplanes from the Wright Brothers experimental department flying over and around Charlotte. They were funny looking with the pilot sitting out in front, his feet hanging down and the propellers backing up. I clearly remember what they looked like. I think I could draw one. Anyway, one would fly over about every month or so and everybody would run out of their houses to look at it. It was quite an experience to see men flying like birds up over our heads.

ARTHUR SANDERS (AN ATTORNEY): We were best friends, inseparable. Howard—we called him "Spike,"—"Mooch" Safferstone, and I—they called me "Sandy"—were the three musketeers. We were together all the time. Every afternoon we'd go down to the drugstore on the corner of 23rd and Arch. The three of us would meet there and talk about the things kids talk about, whatever that was. And I always enjoyed going to the Stern house.

VIRGINIA STERN (HOWARD'S SISTER): For a while our life at home wasn't our own. We had to run through the house to avoid Howard, who was always taking candid photographs of us. Fortunately that didn't last too long. I remember another time when foul odors would emerge from behind his workroom door. He was always getting into something.

ARTHUR SANDERS: Howard had a workroom where we were always mixing things together. I remember we concocted something strange that we called "Sanderstern."

GEORGE WEST [TO HS]: What's "Sanderstern?"

HS: It's "Sandster." We each had a little chemistry set. We mixed up some stuff that we thought was a new chemical, and we named it "Sandster."

HS: The attic was mine to use as a studio and darkroom. I had a desk up there in high school, ostensibly to study but really just to play at. I had a chemistry set there, too. I liked to make gun powder and stuff like that. I tried to make ammonium nitrate, but I never could make it work. It wouldn't explode. I guess it's a good thing.

The entire character of my future—the entire future of my character—was determined when I was in the second grade. The people at school wanted to advance me to the third grade so that I would have to study to keep up. My parents disagreed and insisted that I be kept back with my peers. I had no problems until I got to the fourth grade. Then I found out that I didn't know how to study. Fortunately I had almost total recall, and I got through grade school, junior high and high school by remembering what I had learned in class. I never cracked a book the whole time I was in school. I figured that I was a preordained failure, and I *was* a failure up until I was sixteen.

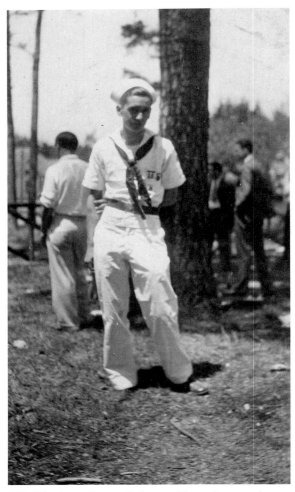

HS: That's me in my Culver uniform. It was taken out at the country club just after I got home. The medals are for expert marksmanship. (1926)

I went to summer camp at Culver for four years. I spent the first one in the Woodcraft School, then three years in the Culver Summer Naval School. I didn't do a thing the first two years I was there except have fun and win a couple of shooting medals.

Then the last year when I was a first classman, I got there two weeks late because I'd had to go to summer school. I went along with my class for a while but I wasn't getting anywhere. I was getting bored with it so I dropped out. I told them that I didn't give a damn about graduating, so they said OK. It stayed that way until two weeks before the end of the summer when I got to thinking that I'd been there all those summers, and my folks expected me to come home a failure again. So I decided that I was going to change things around. I went and talked to the Commander of the Naval School. He didn't seem enthusiastic, but he said I could try if I thought I could do it.

I went to work and passed navigation. I qualified as quartermaster, coxswain, and boatswain, I think. I'm not sure if I made boatswain's mate or not. I got the bronze and the silver Tuxis—that's some name dreamed up by the academy for another series of tests we could take on seamanship—and I was within two points of the gold when the summer ended. I also became the engineer of the school's motor yacht—I had a knack with engines. I graduated with my class. That was the first time I ever got off my ass and did something. I knew that I didn't have to fail but I was conditioned. I still didn't do much better in school and kept making Cs and Ds.

But you know, you can do anything you want to if you're willing to work hard enough. The motto we were given at Culver was "I can if I will." Years later I designed my bookplate with that motto translated on it: *Possum si erro.*

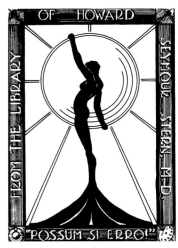

Bookplate (1938)

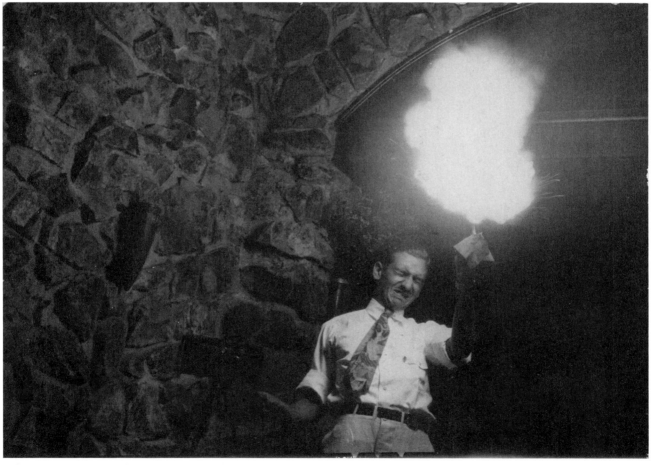

HS: I'm using magnesium flash powder in this one. We didn't have flashbulbs yet. I was taking a group picture. Steve Freund, who was sitting on the front row, had a camera on his lap and took this picture of me at the exact same time on the same flash. (1929)

HS: That's a self-portrait. There's the handkerchief I focused on and forgot to take down. It was taken about 1932 in my backyard on Broadway.

College Years and Medical School: 1928 - 1936

Howard began his college career at Washington University in St. Louis, Missouri. Then after two years of pre-med courses at Little Rock Junior College (now the University of Arkansas at Little Rock), he entered the University of Arkansas School of Medicine.

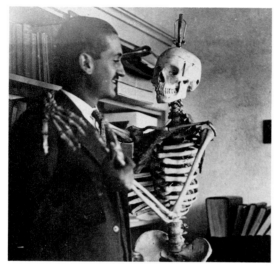

HS: I gave Eleanor a copy of this one. We were going together back then. When we saw each other again in 1976 she told me that she still had the picture at home. (1931)

HS: My father didn't much care what I was going to do when I grew up. I had no encouragement from him until just before I graduated from high school. He asked me what I wanted to do, and I said I didn't have any idea. He asked if I wanted to become an architect and join his firm. I said that'd be alright with me. I didn't care one way or another, so I was enrolled in Washington University School of Architecture for a year and a half. But I still didn't know how to study and I didn't have any real interest in architecture. To tell you the truth, I spent a lot of my time over in the art school playing with the etching press. And I flunked out.

Then I worked in my father's office back in Little Rock without any remuneration or any consideration except that I was supposed to get interested in architecture. My dad's firm was quite profitable and very prominent. He was doing most of the big buildings around Little Rock and the state. He designed Little Rock Central High School, the YMCA, the Albert Pike Hotel, the Arkansas Consistory, the Arlington Hotel and Fordyce Bath House in Hot Springs—and many other notable buildings.

Well, I worked in his firm for that year and a half and still didn't get interested in architecture. I had flunked out of architecture and really flunked out of my dad's office since there was nothing for me to do there but sit and stare out the window. I taught myself to draw and to paint a little, but he wasn't interested in that. Then he offered to send me to medical school.

The one thing for which I am really thankful is that, due to my fear of flunking out of medical school, I really turned around and taught myself to study. It's a matter of what you're interested in. I wasn't interested in becoming an architect. I wasn't motivated. If I'd flunked out of medical school first and then gone to architectural school, I would have studied and passed that. I knew that medical school was my last chance. You do it or else. When I got into medical school, it got hard. I really sweated blood. The anatomy and neuroanatomy that first year were awful; I sat down and practically memorized Gray's *Anatomy*, but I got through it.

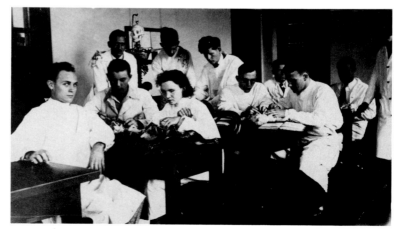

HS: That's pre-med. Most of those people graduated and became doctors. (1931)

Study in Shadows (1928)
gelatin silver print, 7 $\frac{1}{2}$ x 10 $\frac{1}{2}$ inches

HS: This was my first serious photograph
GW: Did you know you were getting it?
HS: Yes. I composed it very carefully. I had my camera on a tripod and I think I had roll film in it. I hadn't gotten the ground-glass back for the camera yet. Eventually I bought one and it took cut film and glass plates.

Art: 1928 - 1941

Despite the rigors of pre-med, medical school, and interning, Howard turned to artistic pursuits with a passion. Indeed, these were years of intense motivation and creativity. In addition to photography, he was finding other outlets for expression. His earlier interest in etching led to linoleum block printing, and he began experimenting with watercolor painting. He was also keeping a journal of prose and poetry, and he wrote a one-act play, a Faust parody, that was produced at Little Rock Junior College.

JAMES T. RHYNE (A PEDIATRICIAN): Howard and I became close friends at junior college. We just hit it off. Both of us were involved in writing for the college newspaper. I liked his wit and the humor. Puns were one of his favorite things.

We did photography together. I learned to do some of the mechanics of photography with him, but I never did learn to see or compose like he did, which he did beautifully.

HS: When I was doing my internship at City Hospital I had my enlarger in my room. On slow nights when I didn't have anything in particular to do, I would print.

ARTHUR SANDERS: I'd go down there all the time in the evening and we'd process photographs. But even before that, of course, he was interested in photography. In fact, he was probably one of the finest photographers around here.

GW: Where'd you get the idea to do linoleum cuts?

HS: I'd seen linoleum prints up in Dad's office. One of the draughtsmen there did them. I did them in my first medical office in the Exchange Building. I didn't have any patients yet so I'd sit back in my lab and cut them to kill time and keep from going crazy.

GW: It seems that your art flourished while you were studying medicine.

HS: It saved my sanity.

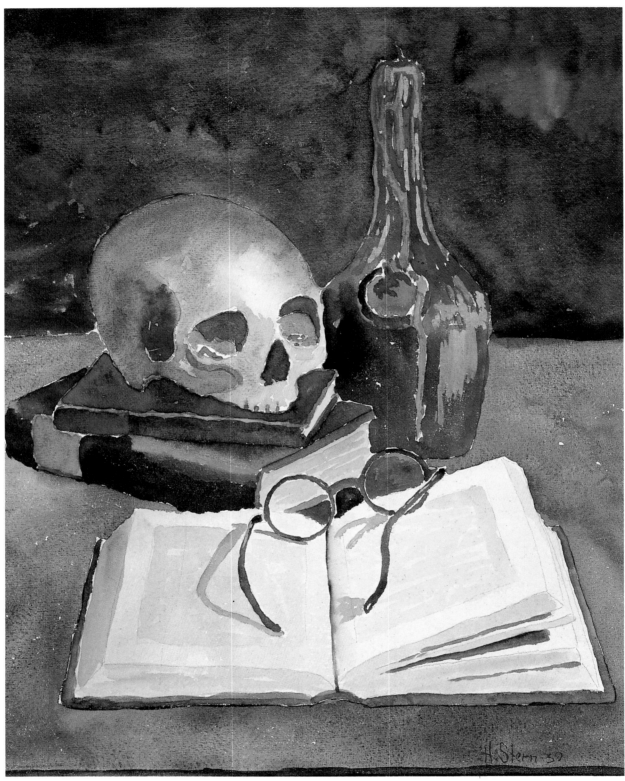

Thanatopsis (1939)
Watercolor on paper, 17 1/4 x 13 1/2 inches

Photograph by Cindy Momchilov

Excerpt from
Aw, Goethe the Devil
(1931)

Act one, Scene one

Scene One takes place in the den of Dr. Faust (the Konjoin Man). On the walls are pennants from Drake University, Leland Stanford, and College of the Ozarks. The venerable doctor is pacing to and fro among the books, dirty clothing, and scientific apparatus scattered about the room. He mutters passionately into his long white beard.

Dr. Faust:	Wurra, wurra, wurra! So I'm gettin' old, am I? Wurra, wurra! *(He becomes very angry.)* Too old to operate, huh? Why those knife slingin' old fossils! Tellin' me I'm too old to push a knife! Why I'll ... I'll *(Up pops the devil. He is dressed in frock coat, top hat, and striped trousers.)*
Mephisto:	Tut, tut, Grandpop, look out or you'll bust a blood vessel!
Dr. Faust:	*(Sputtering)* Putt, putt! Er ... ah ... uh, say! Who the devil are you, and what the deuce do you want? Waddaya want? Howja get in?
Mephisto:	Putt, putt? You know, you sound just like a motor boat. But you must permit me to introduce myself. I am his satanic majesty, Mephistopheles, and a hell of a good guy. *(He chuckles.)* Not bad, wot? My pals call me Mephisto. You can if you wish.
Dr. Faust:	Aw, heck, why doncha go 'way and let a guy worry in peace? Haven't I got enough to bother me without you buttin' in with your rotten puns? Gwan! Scram!
Mephisto:	Don't get sore, Doc, I didn't come here to bother you, I came to help you. I know how you may become young again. Several ways, in fact.
Dr. Faust:	Oh, yeah? For instance?
Mephisto:	Well, you could take the Steinach Treatment. The changes that they've been making, I hear, are simply gland! *(More chuckles.)*
Dr. Faust:	I tried that and it didn't do a darn bit of good, and the next time you pull one of those lousy puns I'm gonna hand you one. For heaven's sake, cut it out! I hate 'em!
Mephisto:	Sorry. Well, if you don't like the gland idea, I have here a bottle of stuff *(holds up bottle of Pluto Water)* that I'm sure will make everything come out all right. If it won't make you young, nothing will. Try it once and see for yourself.
Dr. Faust:	Thanks, but a man who makes one patent medicine doesn't usually care to trust any of them. Nope, not today.
Mephisto:	What? Don't want it? Well, give a look at that. *(Margurite enters from the wings, turns, departs.)* How'd you like to own it? She's yours if you take a drink and will me your soul when you croak.
Dr. Faust:	Gad! Wot a By-utey! Gimme that bottle. *(He drinks and falls asleep.)*
Mephisto:	*(Rubbing his hands together.)* You poor sap! *(He chuckles and exits.)*

Curtain

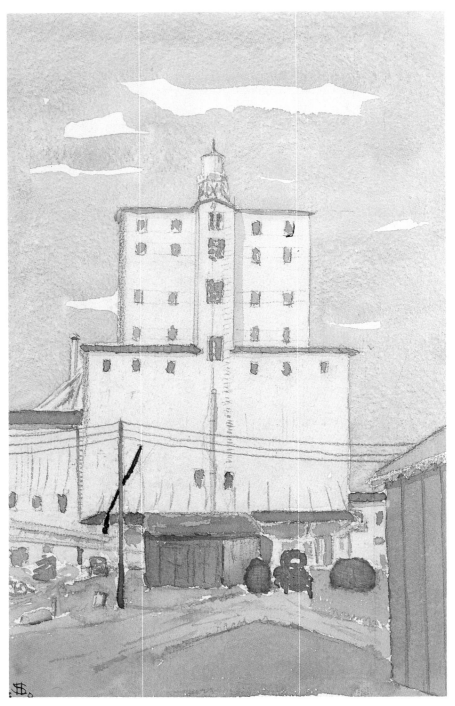

Grain Elvator (1930)
Watercolor on paper, 11 1/8 x 7 inches

Photograph by Cindy Momchilov

HS: This was my first watercolor painting. It won a five-dollar first prize in the first Arkansas Artists Competition.

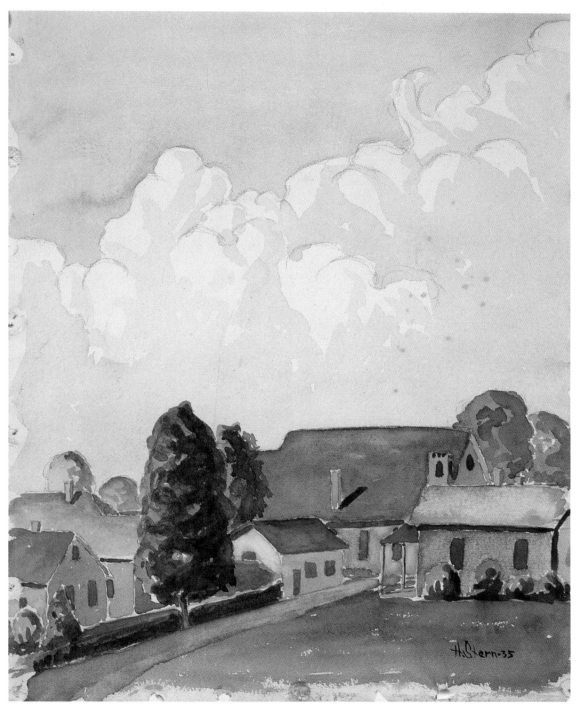

Untitled (1935)
Watercolor on paper, 14 1/4 x 11 1/8 inches

Photograph by Cindy Momchilov

Untitled (1930)
Ink, 15 x 11 inches

Photograph by Cindy Momchilov

Evening (1941)
Linoleum cut, 8 ¹/₂ x 7 ¹/₄ inches

Photograph by Cindy Momchilov

HS: This was the last linocut I did for many years.

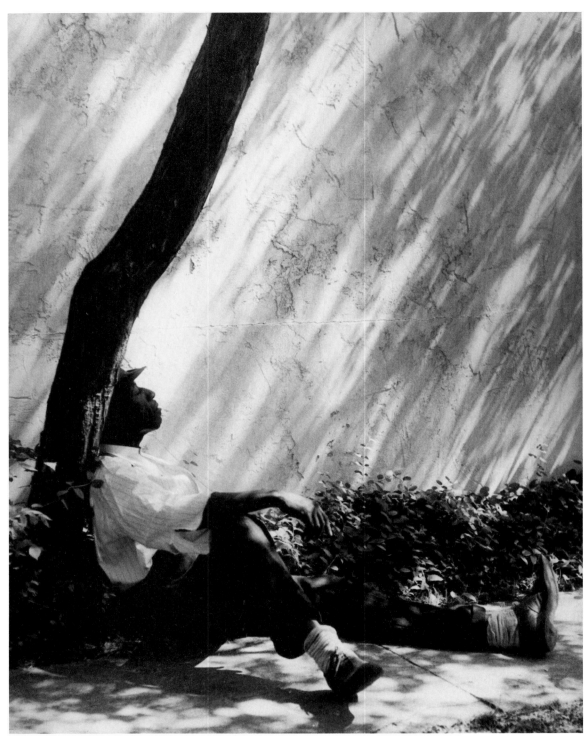

Sweet Repose (1935)
Gelatin silver print, 13 ¹/₄ x 10 ¹/₄ inches

In 1935 Howard helped organize the Little Rock Camera Club, a group of like-minded and equally serious photographers.

ARTHUR SANDERS: We got together and decided we'd like to have a camera club. There were the Hamer brothers—Chilton and Curtis, Ed Smurl, Bill Hughes, Percy Bliss, Judge Troy Lewis, and Julian Priddy, who was also one of the fine photographers along with Thomas Harding.

HS: At the beginning, for the charter meetings, there were only about four or five of us. We kept going to meetings. We were all serious photographers. After a while there were about twenty-five of us. We began getting a lot more members—some U.S. Engineers, some local photographers.

Back then my equipment was crude. My enlarger was homemade, and it wasn't all that easy. It was a problem because my enlarger consisted of the camera I took the pictures with and a lamp house I built so it could go up and down.

GEORGE WEST: What were the other people in the Camera Club using? Were their enlargers homemade, too?

HS: No, a lot of them were out in the world already. I was still in school. They had money to buy this stuff with but I didn't, so I had to make it. That was a challenge, too.

We constantly competed with each other. Every time we had a meeting, it was understood that everyone would bring a print. We'd take turns critiquing them. As long as we did that we had a good time.

HS: That's me working up in my attic studio (c. 1934)

HS: That's a candid shot someone took of me at a Camera Club meeting (1939)

ARTHUR SANDERS:
We met and talked photography at a building over in the Hillcrest area. We would show recent photographs and tell how they were made, about the process. It was supportive; everybody would ask questions: "Gee, that's pretty. How'd you do it? What f-stop did you use? What is it printed on?" We were always trying out new printing paper.

We also used to meet at the Revilo Hotel out on Markham Street where Julian Priddy had an apartment with a darkroom. The hotel was owned by Mr. Oliver. See, Revilo is Oliver spelled backwards. Julian had a pretty nice darkroom, and we'd go there and talk.

The Camera Club didn't go out as a group, but Howard and I used to go out picture-taking togeth-

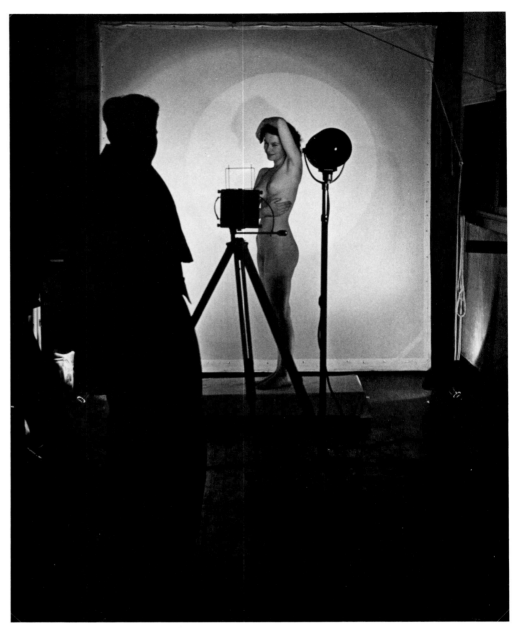

The Studio (1939)
Gelatin silver print, 14 x 11 inches

er. We carried cameras with us all the time. Howard had his attic fixed up as a studio in those days, and we would take pictures up there also. And oh, boy, we were something! He would get some nude models up there. I was studying law at that time, and I wrote up this release that every nude model would sign saying she would not bring charges against us.

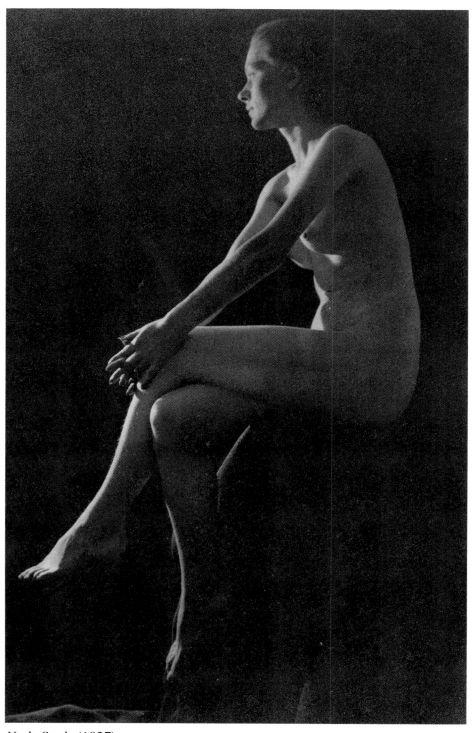

Nude Study (1937)
Gelatin silver print, 13 3/8 x 8 3/8 inches

HS: This is contour lighting from the front. Mortensen, one of the great photographers of the 1930s, described four types of lighting: basic, contour, then two others. Basic lighting was almost right up on it. Everything was fairly white with just outlines. Then you move back and get contour with more shading on the sides. The farther back, the more shading you get.

Although Howard's photographs from this period reflect the prevalent style, the choice of subjects at that time was new to those looking through the lens. His subject matter came from his travels as well as from local outings, studio models and still lifes.

ARTHUR SANDERS: I was talking to Howard the other day about present-day photography compared with old-time photography. Back in those days style was different. We all subscribed to photography magazines. Composition was the thing. We *studied* composition. You'd want to lead the viewer's eye right through the picture to a spot about one-third up from the bottom and one-third in from the edge to the main point of interest.

Our favorite haunts were out in the country. We would go looking for subjects that were different. It seemed to be something to do, to look for things out of the ordinary—things that would look good on paper. An ordinary picture would be just a path leading through the woods or some such. *Out of the ordinary* would be something like close-ups of the fine details of a subject—or unusual lighting.

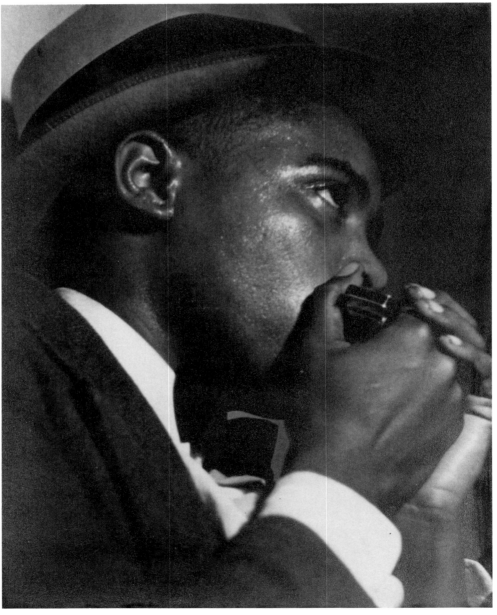

Soul Music (1937)
Gelatin silver print, 9 5/16 x 7 3/8

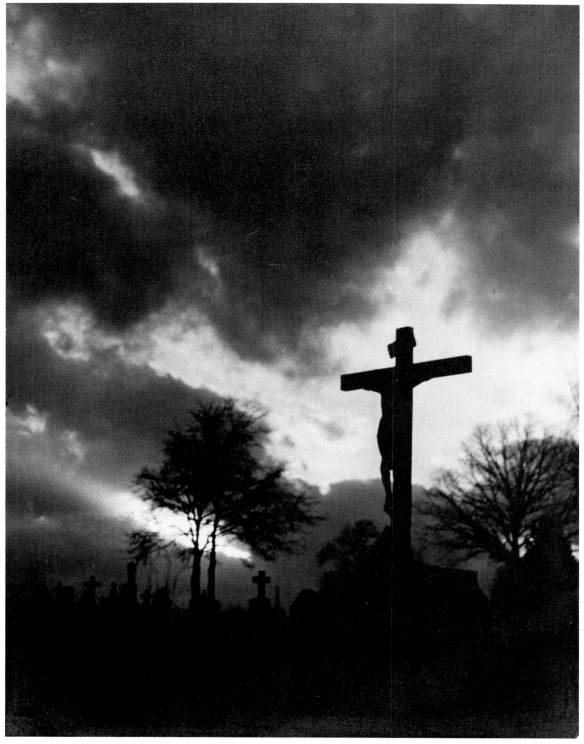

God's Acre (1932)
Gelatin silver print, 9 ³/₄ x 7 ¹/₄ inches

GEORGE WEST: Did you ever go along with Howard on his photographic outings?

VIRGINIA STERN: I remember in particular one outing we took to a graveyard. He had been out there a number of times before. When he saw the clouds building in the sky that day, he came home saying that it was time to go out there and take the picture he'd been waiting for.

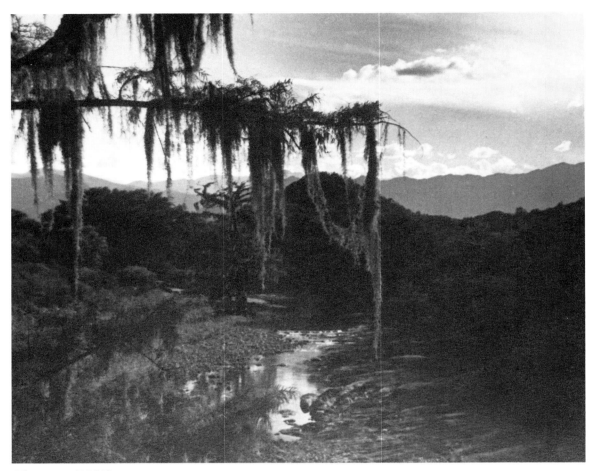

El Arroyo (1937)
Gelatin silver print, 7 1/4 x 8 7/8 inches

HS: Chilton Hamer and I went to Mexico in 1937 after my first year of internship.

GEORGE WEST: What was it like traveling in Mexico in 1937?

HS: There were no real problems. Out in the country the farmers wore six-guns, but they were all friendly. Our biggest problem was the road into Jacala. We got near there coming down out of the mountains after a pretty rough crossing. The road wasn't a road yet. It was just recently blasted out of the side of the hill. It was rougher than hell and we had a blowout. Thank God that was our only puncture because we only had one spare tire. We went all the rest of the way to Mexico City without a spare. When we got down the hill we were hotter than hell so we found a hotel, bought some beer, and sat up on the porch. That was the best bottle of beer I ever drank!

GEORGE WEST: Were there particular photographers whose work influenced your vision?

HS: Steichen, Stieglitz—all those people.

GW: How did you get access to their work?

HS: Photography magazines mostly. Those guys were still living and their work was all over the place.

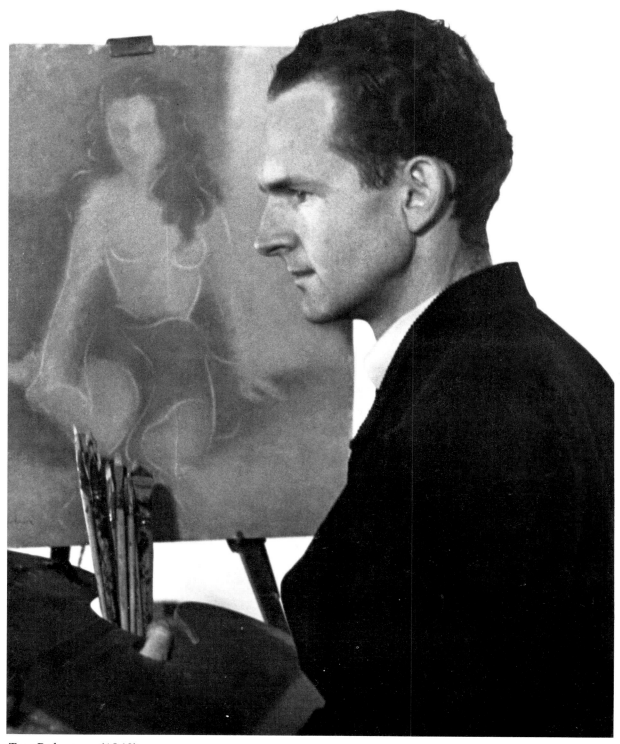

Tom Robertson (1940)
Gelatin silver print, 13 ¹/₂ x 10 ¹/₂ inches

HS: Tom Robertson gave me the best impression of the evolution of making art. He was doing realist paintings back in the 1930s. Then all of a sudden he quit and didn't do any painting for a while. Then he started coming out with non-objective designs in silk screen. There he was, all of a sudden doing something totally different in a new medium.

Art photography was carried along by a popular movement in the first decades of the century. Camera clubs and salons (competitive exhibitions) spread from Europe to the United States. The goal of many aspiring photographers was to have prints accepted by a salon.

ARTHUR SANDERS: Back then we took every picture with the intention of enlarging it to eleven by fourteen, mounting it, and sending it off to a salon to be hung in an exhibit. We had to compete with pictures from all over the United States and wanted it to be as good as we could make it, in terms of composition and texture and tone. Howard seemed to have the knack of being able to do that as well or better than anyone else I remember. He would take a picture and work on it. He sent pictures to salons all across the country and out of the United States.

HS: In the back of *American Photography* there was always a list of salons and the opening and closing dates for submitting prints. Once you got accepted at one or two of them, the rest of them—they'd pass the mailing lists around—would send entry forms. Salons were very popular then. Every country had them.

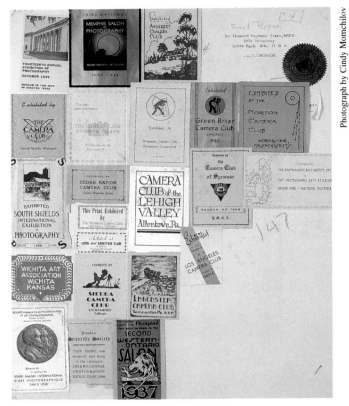

Photograph by Cindy Momchilov

Salon stickers attached to the back side of the mat of *Sweet Repose* showing where it was exhibited

When I started getting into the salons it was like dope. I had to exhibit. I'm a pot hunter and I went after those stickers on the back of my prints that told where I'd exhibited. I really went after those. I won a medal in Hungary, and I sold a print out of a Paris salon to a greeting card concern on the Isle of Wight.

The entries I sent were mostly local genre. I didn't use that consciously. I was just looking for pictures. It didn't matter much to me where they came from.

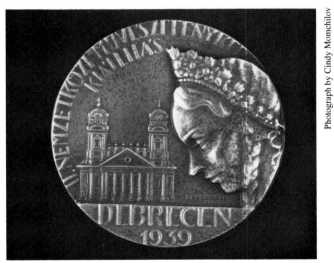

Photograph by Cindy Momchilov

Bronze medal awarded for *Design for Tapestry* in 1941 by the salon in Debrecen, Hungary

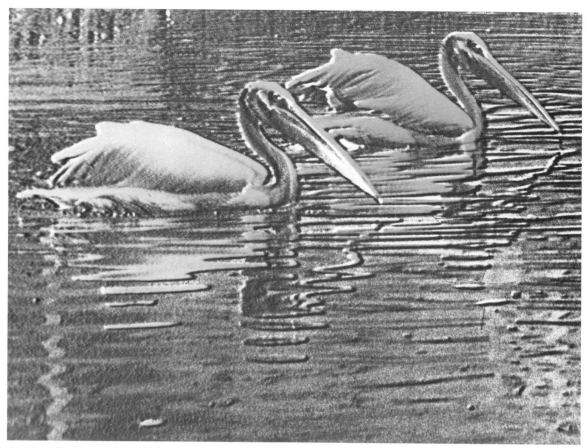

Design for Tapestry (1938)
Gelatin silver print, 10 ½ x 13 ½ inches

HS: This is my first print that won a prize. It won a bronze medal in the Hungarian Salon in Debrecen in 1941. Then it went around—I guess it hung in ten or fifteen shows all over Europe and the United States. The two birds were out on the pond in Central Park. I enlarged them on a glass slide and made a positive. Then I turned it over on another glass slide and made a negative. Then I glued the two together slightly out of register and printed through them. It's a bas relief.
GW: Where'd you learn how to do that?
HS: I was just experimenting. I tried it with several other negatives but it never again worked as well.

GEORGE WEST: Did you ever consider trying to be a professional painter or photographer?

HS: No, it was suggested to me when I was an intern that I went into the wrong profession, that I should have been a photographer. That came from the laity, not from the professionals. I said no, I'd go nuts trying to do that professionally. I saw too many artists struggling to make a living.

ARTHUR SANDERS: Howard never did talk about going off full time to make his fame and fortune as a photographer. I don't think he had any desire, but he could have been one.

We were closer in photography than in anything else. That was his burning desire—to make photographs constantly. It was always his ambition to take that next picture, to make something really good out of that next picture. We would carry our cameras around always looking for something that might turn out to be THE picture.

HENRY MARX (A RETIRED MERCHANT): I would describe my work as commercial photographhy. The question I always ask is would it sell. Howard, on the other hand, is an art photographer.

The Cynic (1939)
Gelatin silver print, 13 ½ x 10 ½

HS: This one got hung in a lot of places. The Camera Club gave him five dollars to come in and pose one night. Of course, five dollars was a lot of money then, but each member of the club got five minutes with him. That picture is the result of my five minutes. We think that he was a Californian who had a brother left over from World War I up at the Veteran's Hospital. Every year on his vacation he'd hitchhike here to visit, then hitchhike back.

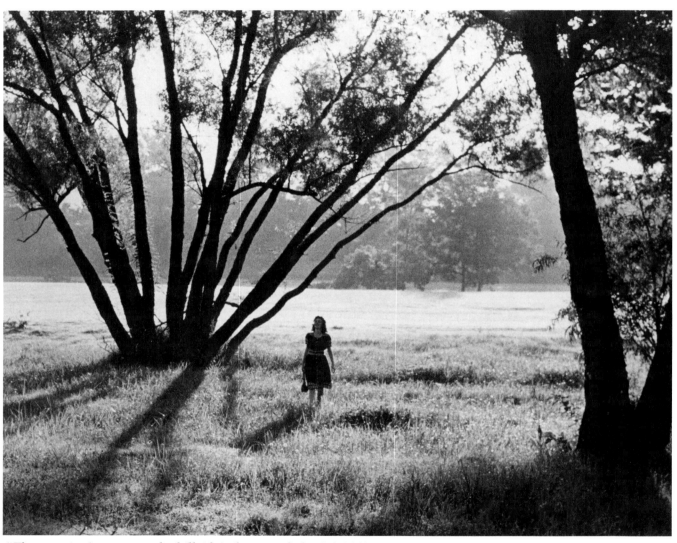

"The morning's at seven, the hillside's dew-pearled...." (1939)
Gelatin silver print, 13 x 16 inches

Marriage and the War Years: 1939 - 1946

Howard's zeal for photography waned with the onset of World War II. The war years also marked the beginning of a new family life. He married Little Rock native Jane Ellenbogen in 1940. They lived with his family in the house on Broadway until shortly before their first child, Arthur, was born in 1944; daughter Ellen arrived two years later.

HS: When I first started practicing, Jane and I couldn't afford to get married. We had to wait for two years.

 I started out as a general practitioner in 1938. My first year in practice I grossed two hundred dollars. My second year I did better—I made eight hundred dollars. It wasn't until the third year that I made enough to keep any of it.

GEORGE WEST: Did Jane recognize how important your art was to you?

HS: Yes. She used to go out painting with me. We'd go out what we then called the Old River Road. We'd take a snack with us and set up a couple of chairs. I'd paint and we'd chat and enjoy each other's company. Then we'd go back to her house or whatever. That's the way we spent a lot of Saturday afternoons when I wasn't working. She was very helpful. I took her out with me a lot of times when I photographed. She's the subject of several of my pictures—two of my best ones.

GW: What would she do while you were photographing?

HS: Keep me company mostly, and if I needed a figure she'd be the figure. On one of our outings we went over to the old Riverdale Golf Course. There were some beautiful trees out there. We got up real early one morning and got out there by dawn. Then just as the sun came up through the trees, I had her walk up through them and took a bunch of shots of her—and made one of my best pictures, the one I call *The morning's at seven, the hillside's dew-pearled...,* " except that it wasn't spring. It was September 1, 1939. When we got through taking pictures, we went back to her house for breakfast. I took the paper in, opened it —and boy! There was the headline: "Hitler Invades Danzig." It was the day the war started.

GW: Were you involved in World War II?

HS: I had been commissioned a first lieutenant in the Medical Reserve when I graduated from medical school in '38. The day after Pearl Harbor I went up to Camp Robinson to see Colonel Blake and said something like, "My country's been attacked and here I am!" You know, big shot! He said to go home and that they'd call me when they were ready for me, but he sent me to get examined. The minimum weight requirement was 122 pounds and I weighed in at only 118. So they turned me down for active duty. I stayed in the reserves until 1943, when they gave me an honorable medical discharge and put me to work with the Selective Service. Of course, I'd been working with the Selective Service all along. And that's how I spent the war, examining draftees and volunteers. I probably examined more than fifty thousand men.

 When the war started I dropped out of photography. Everybody was going to war and there was no fun in it anymore.

Howard and Jane with Carolyn Tenenbaum (1940)

Photograph by Percy Bliss

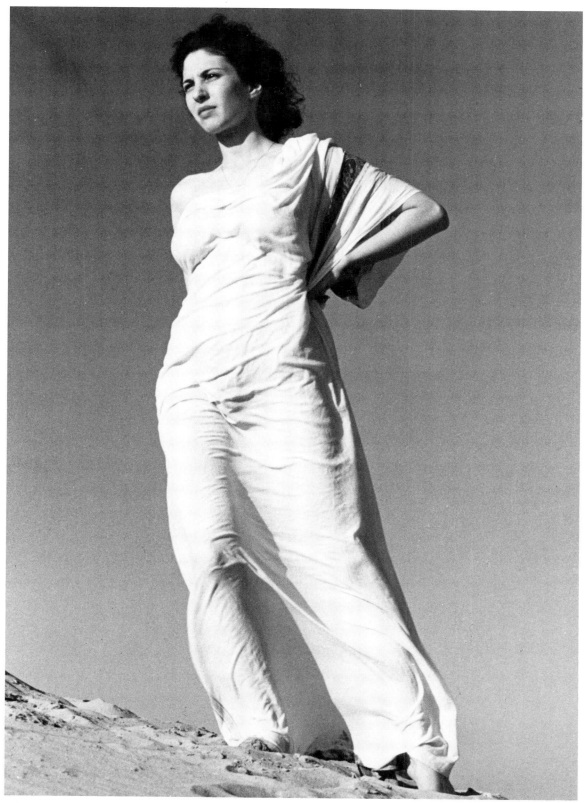

The Figurehead (1940)
Gelatin silver print, 9 5/8 x 6 3/4 inches

HS: This was on a sandbar in the Arkansas River. We went there with Julian Priddy and Jane Cazort. They went to take their pictures, and Jane [Stern] and I stayed on this hill. She put on a wet sheet and stood in the wind for this picture.

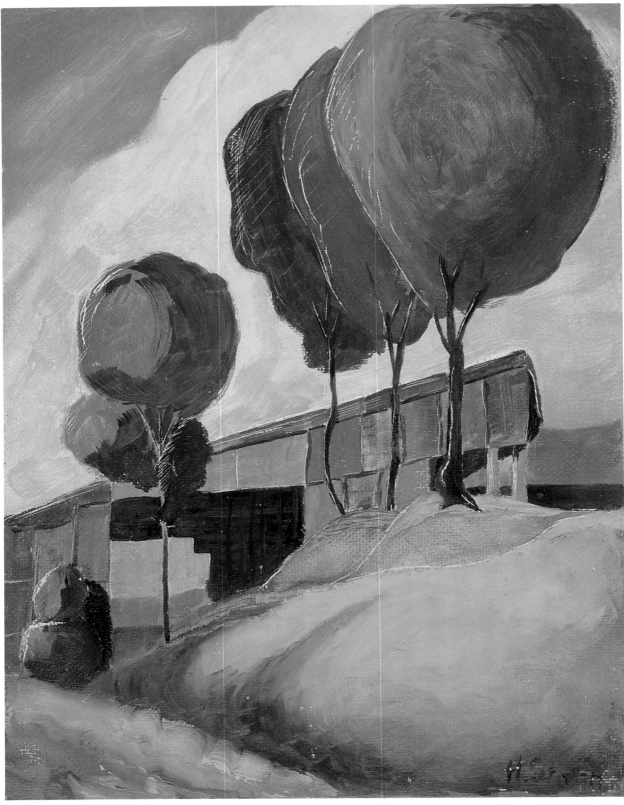

Untitled (c. 1944)
Oil on masonite, 16 x 12 inches

Painting and Ars Medica: 1941 - 1947

In 1941 Howard put down the camera and picked up the paintbrush. In place of the Camera Club, he kept company with a smaller but equally dedicated cadre of artists who called themselves the Ars Medica Tobacco Road Club.

George West: How did you fall in with the Ars Medica group?

HS: It was a spontaneous thing. I was talking to Adrian Brewer—he was one of my patients—and said it'd be nice if we went out painting. Howard Bragg and Lloyd Wilbur wanted to go, and Clarence Koch, too. Spider McCullough came in a little later. He was Professor of Anatomy at the medical school. We were all doing oils then. That was from about 1941 to 1944. Adrian and Howard were the "ars" part. Lloyd Wilbur, Clarence Koch, Spider McCollough, and I were the "medica" part.

Every Sunday morning we'd meet at Adrian's house and then go out on Tobacco Road, which was down underneath the viaduct off Cantrell Road on Wiggley's Island where Cajun's Wharf is now. We just drove down off the viaduct. There were shanties, a slum area.

We also went out on the south end of town, out Arch Street Pike. There were some shanties out there, too. We would go out on Sunday mornings and just sit and paint. We never saw a soul out there. I guess they'd all gone to church.

GW: Do you recall any particular Sundays?

HS: One day when we were down there an amorous billy goat jumped up and started walking around on Clarence's brand new Cadillac. I thought Clarence was going to have a hemorrhage. He got up and chased it off. Then the goat went over to Howard and started trying to make love to him!

When I was interning I went down there to deliver a baby to a young couple who lived in a tent. That was during the Depression. I got to name their baby, so I named her after my girlfriend at that time, Eleanor, who later became my second wife.

GW: At that time, were you trying to set yourself up for competition?

HS: Not really. I knew I wasn't good enough to compete yet.

GW: Did you critique each other?

HS: We'd get a bottle of wine and take it with us. We'd tie a string around it and put it down in the well to chill it. Then we'd paint a couple of hours, until about noon. Before we'd go home to lunch we'd pull up the wine, open it, and Adrian would give us a critique. He was a real pro. As far as we were concerned, he was Mr. God in the art world. He was THE painter around here at that time. After the critique we'd sit around and jaw about it—what we'd painted and why we'd painted what we did. It was a lot of fun. I think that was some of the most fun I've ever had—especially with Adrian. He was one very funny fellow, also a very fine gentleman and one of my dearest friends.

GW: Was he a full time professional painter?

HS: Yes, he did portraits of most of the well-known people around here at that time. He did the famous portrait of the flag that was so popular during the war years. He taught art classes, but I never signed up because I was too broke to afford them.

HS: We went to paint wherever there were shanties around town.

GW: Were shanties an "in vogue" subject.

HS: Yes, for us, because that's what we could find on Tobacco Road.

EDWIN BREWER (A PAINTER; ADRIAN BREWER'S SON): It was a modern thing—to paint these signs of a passing time—like shanties, old bridges, and barns and such. My dad knew Thomas Hart Benton and used to get on the phone and talk about it with him. Benton's style of American realism and the work of Grant Wood were major influences on my dad's work.

BETTY BREWER RICE (ADRIAN BREWER'S DAUGHTER): The Ars Medica group wasn't just Sunday painters. They were a group of intellectuals—that's what they were. Dad wouldn't have wasted his time unless there was mental stimulation.

 He was excellent in portraiture and made a successful living at it, but it became terribly dull to him. With the Ars Medica group he became more creative and began to experiment with different painting styles and colors. It was a stimulus for all the people in the group, not just Dad.

HS: I wasn't trying to compete. I was just trying to learn how to paint. Adrian showed me how to change the straight lines of buildings, to curve them to give more feeling to the painting. It's like the advice that's often given in workshops—never transcribe, always translate.

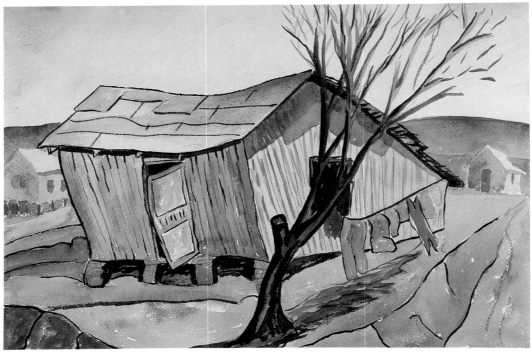

Untitled (c. 1950)
Watercolor on paper, 14 x 20 inches

Photograph by Cindy Momchilov

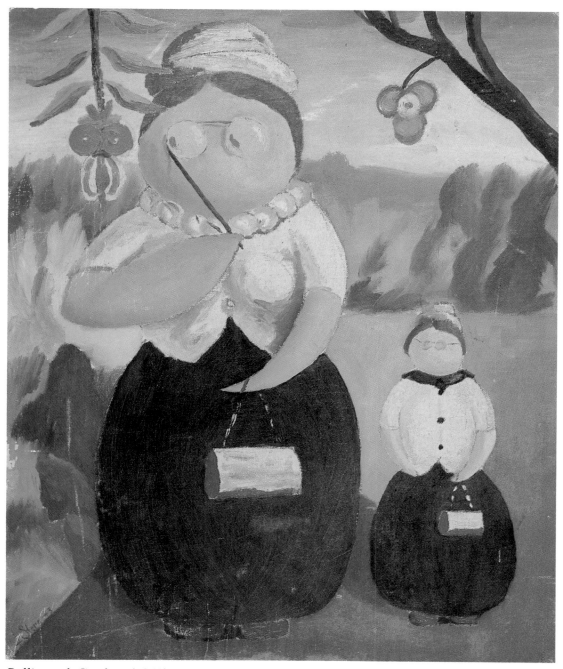

Bellingrath Gardens (1943)
Oil on canvas board, 20 x 16 inches

Photograph by Cindy Momchilov

HS: I did about half a dozen painting in that style—round faces with no features, just forms. Who needs features? That's just a snobbish lady with her lorgnette, being so superior and peering at the flowers. I painted it with my tongue in my cheek.

In 1947 one of Howard's watercolors won first place awards in two competitions. Soon after, his painting reached a hiatus.

HS: A lot of my painting is mood stuff. In fact, one of the first ones I won a national prize with was a mood painting. I called it *Bright Moonlight*. There was an old overgrown black cemetery with a big abandoned house on the hill out old Highway 65 toward Pine Bluff. I saw it when I made a house call out in that area one night. I stopped to sketch it and came home and painted it.

In 1947 I entered it in the Arkansas Artists Competition at Hendrix College. It won first place—a fifty-dollar purchase prize—which I turned down. So the painting was awarded the five-dollar second prize. Louis Freund was artist-in-residence there. He and I had seen each other in passing, but that's when I really met him. We got to be pretty good friends.

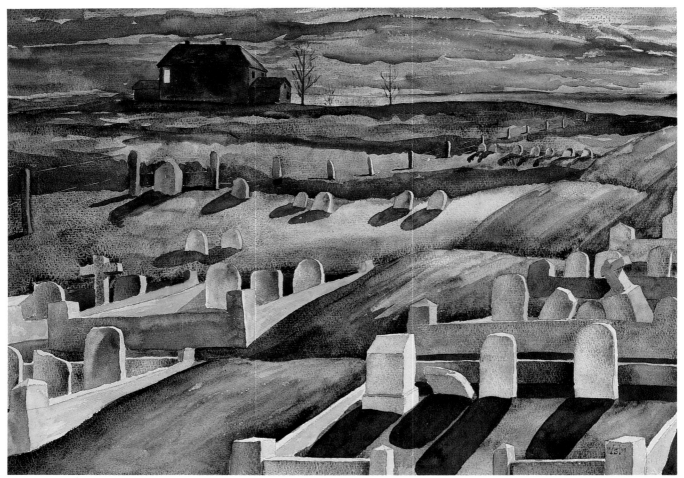

Bright Moonlight (1945)
Watercolor on paper, 21 1/8 x 28 1/2 inches.
(Collection of the Arts & Science Center for Southeast Arkansas, Pine Bluff)

That same painting won the trophy at the AMA convention—the American Physicians Art Association trophy. That was the first national painting prize I won.

About this same time or soon after, I was out with Adrian and Howard Bragg. All of a sudden, Howard and I simultaneously looked at each other and said, "What the hell are we doing here?" Howard said, "I don't know. I've had it. I quit." He packed up his stuff and went home. That was pretty much it for a while. I didn't stay burned out too long that time. Two or three years and I was back painting again. I guess this first one wasn't a conscious burnout period. I just had so many other things to do that I didn't have time to fool with the painting.

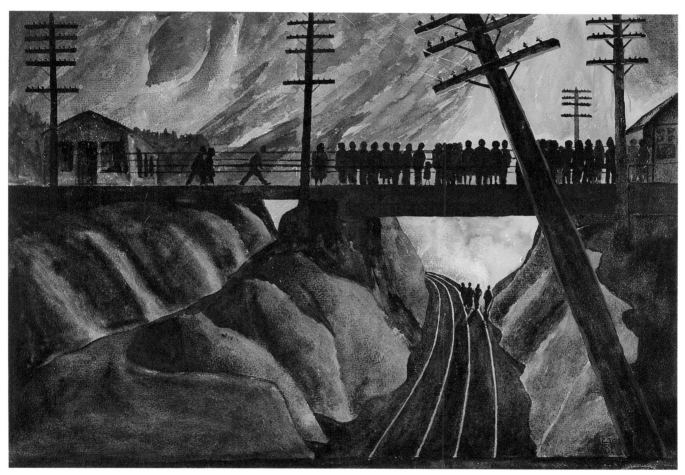

Lumberyard Fire (c. 1947)

Watercolor on paper, 22 $^1/4$ x 29 inches

Photograph by Cindy Momchilov

HS: Jane and I had gone out to dinner with another couple the night the Grobmyer Lumber Company burned, and we stopped on the way home to watch the fire for a while. The next day on my lunch hour I went back with my sketch pad. I started on the painting that night, worked on it in the evenings and finshed it within two weeks. It was a real firestorm when all of those paints and solvents went up and you could see the convection currents. That's what I tried to catch.

The Move to Pine Bluff: 1948

It was a year of transition for Howard's family as well as for his profession. He moved fifty miles south to Pine Bluff to join a three-doctor clinic.

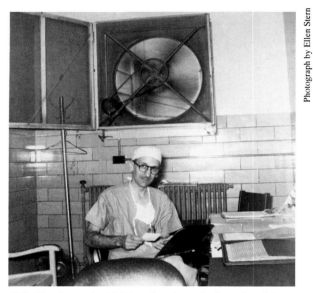

Photograph by Ellen Stern

HS: That's me in 1955 at the chart desk at the old Davis Hospital in Pine Bluff. I had just finished operating.

JIMMY RHYNE: When I started out in college I was going to become an engineer. It was Howard's influence that got me interested in medicine. He was able to paint the idea in enticing pictures about the things you could do. And, of course, all of the young engineers that I could look around and see were lucky to have jobs pumping gas in a filling station. The young doctors didn't have any money either, but at least they had jobs. He laid it out to me as a very enticing, interesting and satisfying field, which I found it to be. When I finished my internship, I knew about a clinic in Pine Bluff that wanted to expand. Howard and I both needed a change so I invited him to move to Pine Bluff, too.

HS: When we first moved to Pine Bluff it was one of my dry periods. I wasn't painting or photographing at that time.

GEORGE WEST: Was that dry period frightening?

HS: I had other things on my mind. I'd moved down there with the family and started the clinic. Then the clinic had problems and blew up in a year, so we were struggling to make a living.

GW: Did that dispirit you in terms of making art?

HS: No, not about art, but it dispirited me about medicine, which I began to hate. I just did it to make a living. Operative surgery was the only part that interested me. I couldn't care less about all the rest of medicine, but I really liked the operating because I'm a mechanic. That's people mechanics. I opened them up, fixed them, and closed them back up.

Pine Bluff, Art and Home: The 1950s

Despite the upheaval of the move and the transition to a solo practice, the early 1950s were artistically productive years. Howard set up a workshop in his house in Pine Bluff and for a while drove back to Little Rock on Sundays to paint with the Ars Medica group. In Pine Bluff he worked with the local Brush and Palette Guild painters.

He took family summer trips to Eureka Springs in north Arkansas to visit and paint with Louis and Elsa Freund. In the mid-1950s he and Jane traveled to Cuba and Guatemala where he made his first photographs in more than a dozen years. But the painting tapered off again, and the photography ended with the trip. Practicing medicine took precedent.

GW: I'm surprised that, if your profession was becoming less and less enjoyable and there was an economic strain, it didn't take away your desire to create art.

HS: It didn't take it away but it didn't do much for it either. I did do some photography again. Jane's grandmother died and left us some money. We had an anniversary coming up and so did our good friends in Pine Bluff—their twenty-fifth, our fifteenth. We signed up together for a cruise to Cuba and Guatemala. I took the camera along. I wasn't consciously creating at that time, but lately I've found some very nice things among those negatives.

GW: Did you feel like a musician who's left his instrument in the closet for years?

HS: You never forget, like riding a bicycle. Once again you unconsciously see things in rectangles. Also, it was a strange country. That was a stimulus. It all came back.

GW: When you got back did you put the camera back "in the closet," so to speak?

HS: No, I didn't put it away. I didn't do much with it, though. For a while I did paintings from the Guatemala trip but then I stopped that, too.

I didn't really need the photography or the painting but I was still painting some. I had burned out on photography and was mostly taking snapshots of the kids.

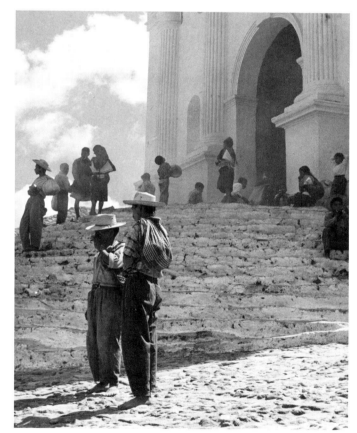

Chichicastenango, Guatemala (1955)
Gelatin silver print, 9 1/2 x 7 1/2 inches

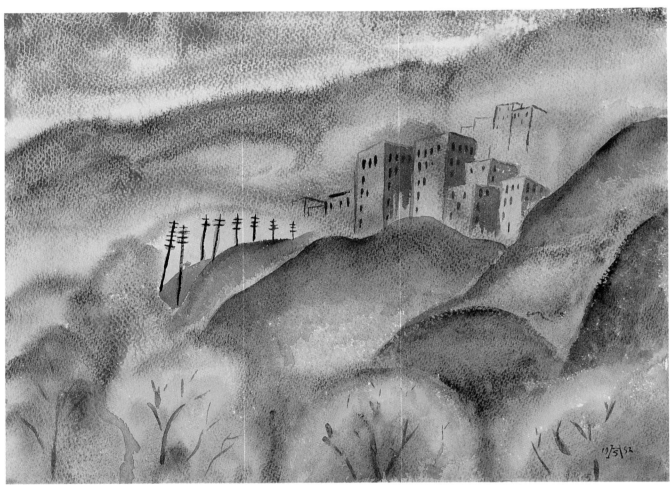

Untitled (1952)
Watercolor on paper, 14 x 18 inches

Photograph by Cindy Momchilov

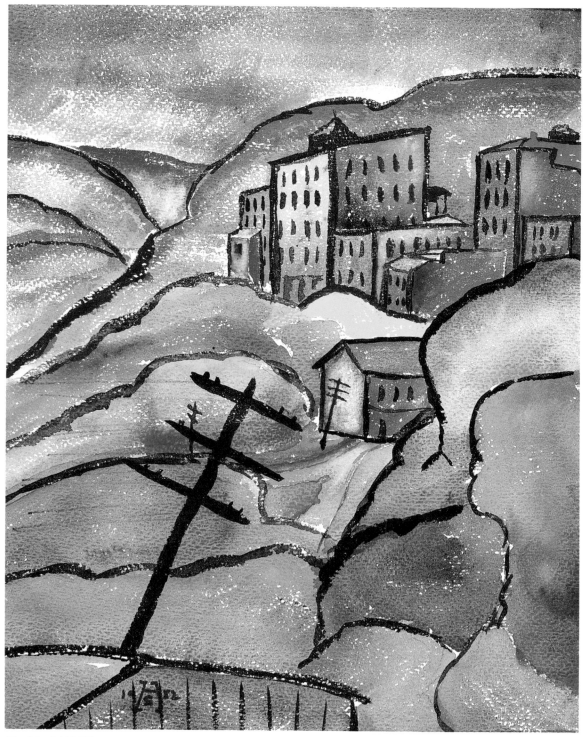

Untitled (1952)
Watercolor on paper, 18 x 14 inches

Photograph by Cindy Momchilov

Untitled (c. 1952)
Watercolor on paper, 15 x 20 inches

Photograph by Cindy Momchilov

HS: When I did these I was just sitting at home playing with paint, trying to see what the colors would do. I was doing a lot of still lifes then because I didn't know what else to do.

Untitled (1952)
Watercolor on paper, 20 x 15 inches

Photograph by Cindy Momchilov

The Stern household as well as Howard's medical office were viewed as unique and creative environments by friends and associates.

ELSA FREUND (AN ARTIST-CRAFTSMAN): Howard was very thorough going. He would investigate and investigate whether he was learning a new technique or doing something else. I remember when his son Arthur was growing up, there was a pond near their house. Arthur and Howard were constantly studying the wiggling things in that water.

ED FREEMAN (FORMER PUBLISHER OF THE *PINE BLUFF COMMERCIAL*): When Arthur conceived the idea of researching "Life in a Mud Puddle," Howard helped him get started.

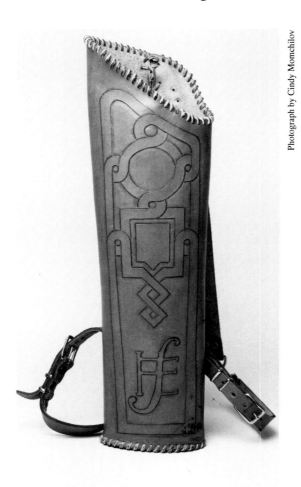

Photograph by Cindy Momchilov

Quiver (c. 1957)
Leather, 21 ¹/₂ inches high

HS: I had a book on signs dating back to the Byzantine Empire. I figured I'd have a sign, too; so I designed one and incorporated all of our initials into it—Howard, Jane, Arthur, and Ellen Stern.

In the '50s the kids got me interested in leather craft. We were doing archery then and I needed a quiver, so I carved our house sign on it.

ARTHUR STERN (HOWARD'S SON): Pop helped me learn how to make photographs through a microscope, and he taught me how to print. He dragged his microscope home from the office every weekend until he found an old microscope for me.

When I was trying to get my Boy Scout stamp-collecting merit badge, two or three of my friends got into it with me, and Dad was a resource for us. He got interested about that time with a collection of his own. I was specializing in the narrow realm of U.S. and San Marino. Dad took on the world and the British Colonies; they're the crown jewels for stamp collections. That was his domain.

CHRIS ANDRESS (CHIEF OF RESOURCE MANAGEMENT AND VISITOR PROTECTION FOR THE MID-ATLANTIC REGION OF THE NATIONAL PARK SERVICE; A CONTEMPORARY OF THE STERN CHILDREN): I remember the Stern home as an unusual household. It was very liberal, especially for Pine Bluff at that time. Dr. and Mrs. Stern didn't hesitate to talk about issues or share their views with a young person. This impressed me, and after I grew up Howard and Jane became two of my first adult friends.

Dr. Stern is a free-ranging spirit, always looking for things to fulfill him. One of the things I remember was that Dr. Stern had the house wired for the hi-fi, and there was always music on.

ELLEN STERN (HOWARD'S DAUGHTER): Daddy has an enormous collection of records, mostly classical. He always had music going on the hi-fi or the radio. He still does. When I was seven or eight and taking ballet lessons I'd ask him to play records for me to dance to. He played one record for me called "Music for Barefoot Ballerinas," which was modern. I never was quite sure how to dance to it, but I'd take off my slippers and try. Then he'd play something from "Swan Lake" or "The Nutcracker." That was more like what a baby ballerina had in mind.

ANNA MAE GARDNER (HOWARD'S OFFICE MEDICAL ASSISTANT, 1955-1966): Dr. Stern was like a teacher, always showing and telling. I went to work for him by chance; I was in an unemployment line with my husband. Dr. Stern hired me, and he taught me that you can do anything you want to do if you want to work for it. Later, at age forty-two, I wanted to go to nursing school. He encouraged me and I did! I'm like an old hound dog—pat me on the head and you have a friend for life. Dr. Stern is my friend for life.

CAROL MORRIS (HOWARD'S OFFICE NURSE, 1966-1980): I remember the pictures he hung in the office. The one I remember most was a bird on a wire teaching the other birds to sing. There were many paintings, too. There was one of a city street, one of a southwest landscape, one of a cypress knee in a pond, and one of water drops on lily pads.

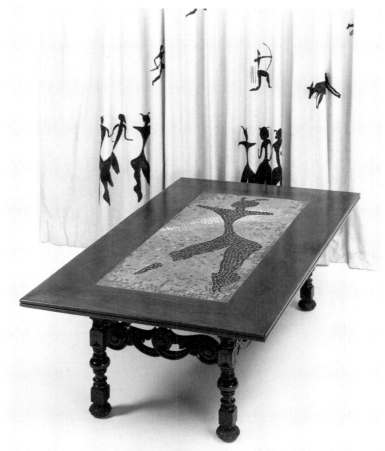

Photograph by Cindy Momchilov

Stenciled Draperies and Mosaic Table (c. 1958)

HS: After we built a new house I wanted to do the living room draperies. I had this lovely book of prehistoric art. I went through it, and when I came to the cave paintings at Altamira I flipped. There was a group of women figures and then there was a group of almost match-stick figures hunting. I stenciled two hunting scenes and a deer mating scene on three panels. All along the bottom I painted groups of women standing watching the men and the animals. Then I made the mosaic table.

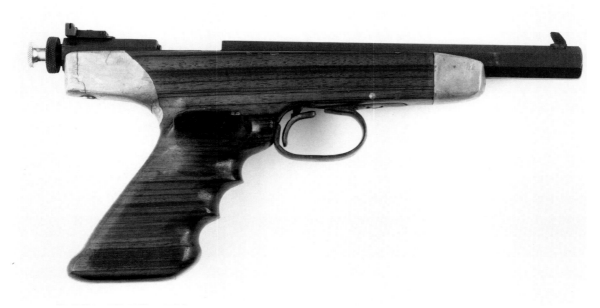

.45 Caliber Muzzle Loading Pistol (1976) Photograph by Cindy Momchilov
African zebra wood/steel/tin

HS: I made thirteen rifles, three pistols, and a couple of Bowie knives.

Target Shooting: 1960 - 1974

By 1960 Howard was pulled back to a former hobby—target shooting. This led to a new circle of friends and a new creative medium—riflemaking.

HS: Moochie Safferstone and I used to shoot with the Little Rock Skeet Club until the war started. We got down to where the club had one last box of shells left, and we couldn't get any more because of the war. On the day we were out shooting that last box, somebody came out in a car and dragged me in to deliver a baby. That was my last baby! I quit obstetrics right then, and I never delivered another one.

Moochie got me interested in shooting again in 1960. I bought a fine set of target pistols, got on the pistol circuit, and collected a lot of medals. I had to quit around 1964 because I got a tennis elbow and couldn't hold up a pistol.

RICHARD KNOX (SERGEANT, PINE BLUFF POLICE DEPARTMENT): Howard Stern was one of my first instructors at the Pine Bluff Boys Club. I still remember the technique he taught in marksmanship. It was very sound: sight, grip, sling up, breathe, squeeze the trigger as your sight sinks down past the bull's eye.

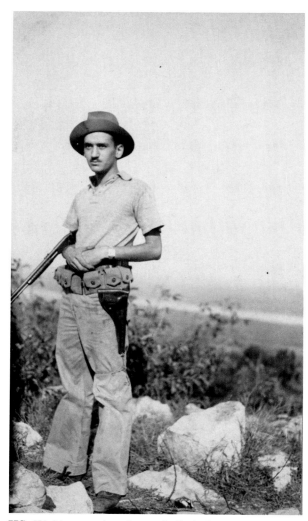

HS: You know, I never would have fired a shot if it weren't for all those medals and cups. I have a hundred and forty-some-odd shooting trophies, including one small national championship and runner-up in another; and I won one regional championship. I wouldn't even have entered if it hadn't been for the cups and the medals. I'm a born competitor, a pot hunter. If there wasn't a tangible reward—doesn't have to be much, a little medal or a certificate or a ribbon at the end of it—I wouldn't have done a damn thing.

W.A. "KNUCKLEHEAD" NILES (FORMER OWNER OF A CAMERA STORE IN PINE BLUFF): That's the main driving force behind Howard, the thing that interests him the most and gives him his kicks—it's the winning or the accomplishments.

And another thing was his association with the gunshop gang. That gave him an avenue to meet a whole new group of people in Pine Bluff.

HS: We'd go out hunting and climb the south face of Pinnacle Mountain every couple of weeks. (c. 1932)

The venue for this new creative path was a gun store in downtown Pine Bluff where "the gunshop gang," an assorted bunch of marksmen, riflemakers, and black powder enthusiasts, held forth each Saturday afternoon.

DAVE WALLIS (A LOCAL HISTORIAN AND WRITER, FORMER MAYOR OF PINE BLUFF): The gun shop mainly sold collectors guns. Grady Newton formed a company of four or five owners to start the business. And they were individualists, all of them. Billy McGee ran the front end, the trading and so forth. Albert Railsback was one of the partners. Now Ralph Bonner wasn't an owner, but he was kind of the resident expert. And Howard was another regular. The rest of them accepted him as one of them and called him "Doc." They called themselves "The Mullets." That's a variety of bottom-feeder or sucker fish.

FRED COLEMAN (A COSMETOLOGIST): I met Howard in 1962 at a pistol shoot on Millington Naval Base in Memphis. We both got to be regulars at the gun shop. Every Saturday afternoon it would be time to go down there—and lie, rib each other, and drink coffee. It came to be known as "Liar's Afternoon."

KNUCKLEHEAD: They were a bunch of practical jokers is what they were, among other things.

DAVE WALLIS: Billy McGee had a gun trap in the back of the store there for target shooting. We would shoot for coffee. The loser had to buy. One time they played a trick on Bonner. They removed the gun trap and he shot a hole through the wall into the vacant warehouse next door.

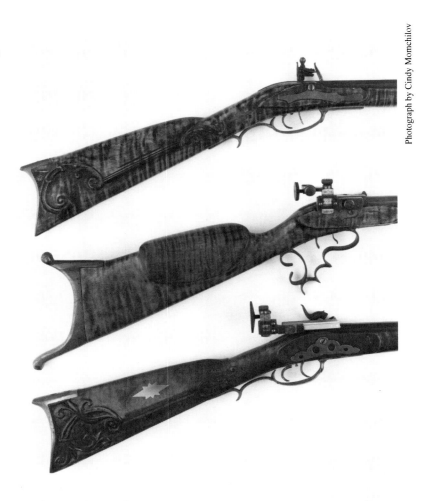

<div style="writing-mode: vertical-rl">Photograph by Cindy Momchilov</div>

Detail of muzzle loading rifle stocks

Arkansas Muzzle Loading Association: 1961

Howard became active in the effort to organize the Arkansas Muzzle Loading Association. Subsequently, he helped lobby the Arkansas Game and Fish Commission to establish a primitive black powder deer season.

HS: I conceived the idea that we should have a state shooting club, so I sent letters to all the shooters I knew. We met at the Marion Hotel and founded the Arkansas Muzzle Loading Association. I stayed involved with the association until I gave up shooting.

FRED COLEMAN: All the other states with muzzle loader competitions had permanent trophies. We thought Arkansas should, too, so we established them. The winners every year get their names engraved on one. Howard donated the Founder's Cup, and there are the Billy McGee and the Albert Railsback trophies. You can see them today in the Saunders Museum in Berryville where we hold the annual matches.

HS: Fred Coleman, Tom Foti, and I went to the Arkansas Game and Fish Commission and asked for a muzzle loading season for deer hunting. We got them to give us one, so I had to go out hunting that first season since I'd been up there pushing for it. I went out with them and I saw a deer, but I wouldn't shoot it. It was too damn pretty.

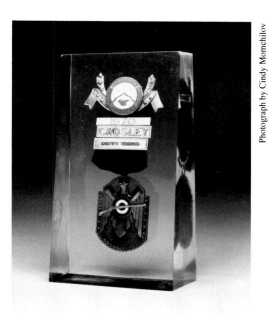

Photograph by Cindy Momchilov

Crosley Medal, National Muzzle Loading Rifle Association (1970)

Kentucky Flintlock (c. 1970)
curly maple/brass/steel, 56 inches

Riflemaking: 1965 - 1974

The craft of riflemaking was a natural outgrowth of Howard's association with the men at the gun shop.

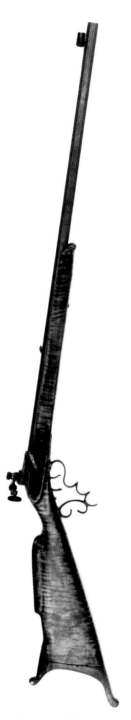

Scheutzen Rifle
(c.1973) curly
maple/brass/steel,
52 inches

HS: I got into rifles and making them. I bought an old Army 30-06 and converted it into a sporter. That was the first one I made. It's a beautiful one. It'll shoot a one-inch group at 100 yards all day long. Then I got interested in muzzle loaders. They're a lot easier to make than cartridge guns. I just went crazy building rifles.

RICHARD KNOX: The gunsmithing followed the shooting. Some folks would get into gunsmithing to improve their weapons. If you were good at it, your friends would ask for your help.

KNUCKLEHEAD: Howard is pretty good at picking up stuff. He's very mechanical minded. He watched some of his associates, took a machine shop class at the Pines Vo-Tech School, and started making rifles. He's quite competitive, you know. If a friend got into something and got interested in it, Howard would try it, too; and if he could do it he would try to outdo the other guy.

ANNA MAE GARDNER: Dr. Stern was really into it. He would bring rifles into the office and work on them when he had five minutes between patients. He would hand rub the finish to make them perfectly smooth.

HS: My gun stocks are certainly sculpture. The bench gun I sold had a stock that was a real work of art. I goofed. I used a piece of African zebra wood for the stock. I fitted it on and everything was fine. Then I was going to shape it and put in a nice Monte Carlo you could go to sleep on while you're shooting. I had it in my router and was cutting when all of a sudden I noticed that the damn thing was tilted and I cut a slot on the outside that was too deep just to ignore. I had to do something. So I remembered what my friend Ralph Bonner had told me—that a fine craftsman is not one who never makes a mistake but rather one who knows how to take that mistake and cover it up so that it looks like he did it on purpose. I got to thinking about that and I worked up some flower designs. Then I carved flowers all over that stock. It was beautiful. I sold that gun for six hundred dollars. I made it because it was a challenge. It challenged me to do something that I'd never before done. I accepted the challenge, went to work and figured out the problems as they arose.

Then I designed and made a portable benchrest. I ripped a 2 x 12 into one-inch pieces and laminated them. I glued and bolted them together with the grain reversed so that it had unbelievable strength and would never warp. Then I put big hinges on the bottom so it would fold up. I was told that I should patent it.

FRED COLEMAN: Howard is a problem solver. After he started shooting muzzle loaders he was noted for trying all kinds of ways to improve his shooting. He used filters from his cameras and things like that to improve the sights on his rifle. At times, people would come down the shooting line and hee-haw: "There goes Howard again." But he didn't let it bother him. He kept trying things until he found ones that worked, and he kept getting better.

Muzzle Loading Championships: 1970 - 1974

The experiments in riflemaking paid off in marksmanship at regional and national shooting matches. Then Howard switched directions.

HS: I made my first trip to the national matches in 1960. Then I went back in 1970 and every year through '74. Strange thing—every year I went up there I was in the winner's circle. I never came home without a trophy. Also, the family never had to buy a turkey at Christmas because I always won one at shooting matches.

I shot a fifty out of fifty in Tennessee at the Dixie Matches. That's how I got into the Davy Crockett Club. I was the eighteenth member. Charlie Haffner, who owned the land where the matches were held, got sick after that and they didn't have many more Dixie Matches, so I think I may be one of the last members.

The Crosley's the one I'm proudest of. Three years later I was runner up for the national benchrest championship. I figured that was about as far as I could go, so I gave up shooting and went back to my watercoloring.

FRED COLEMAN: It's taken me years to understand why he quit. I didn't understand at first. When Howard threw in the towel all I understood was that I had lost my shooting buddy. I missed just having him on the line, knowing he was there at a meet. He is just like a father to me. We would sit and talk for hours about ways to do something in the shop.

I couldn't reckon with it at first. But he had done it and was ready to move on. I'm the same age now that he was then, and I feel like he did—if I can't participate at the same level I'm not going to stand around and make a fool of myself.

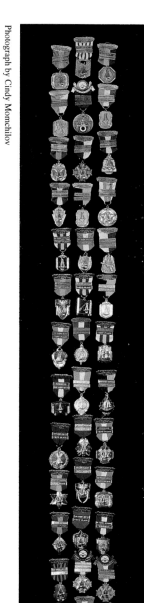

Photograph by Cindy Momchilov

Display board Howard made for some of his shooting medals

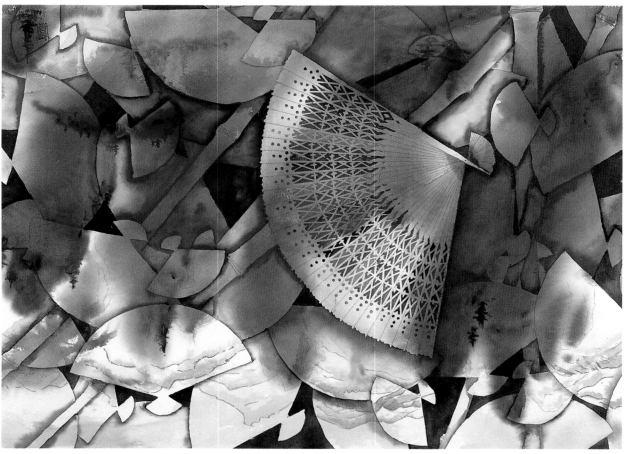

Chinese Fan #2 (1980)
Watercolor on paper, 22 x 29 inches

Photograph by Cindy Momchilov

HS: This one was fun. Linda Flake went to a workshop in China and brought me a little fan that got me going on a series of them.

Painting and the MidSouthern Watercolorists: 1974 - 1981

Howard returned to painting as the outlet for his energies. He told a local newspaper reporter at the time, "I wasn't growing. I looked around for some more skills and new challenges." He found the opportunity for both with the MidSouthern Watercolorists, an organization formed a few years earlier by a core of other watercolor painters in the state. Howard achieved Signature Membership in 1981.

EDWIN BREWER (AN INITIAL BOARD MEMBER OF MSW): We became official in 1970—the MidSouthern Watercolorists. We scheduled paint-outs where members could meet each other and paint together on location. We sponsored demonstrations, organized an annual competitive exhibition, and brought in well-known painters from the West Coast and the Southwest to lead workshops.

I remember Howard being very innovative and loving to experiment. He wasn't the type to stick with one thing. He might develop an idea or a technique in four or five paintings—a sort of mini-series—and then he'd learn a new technique.

HS: That fan painting on the wall there, which won a silver medal at the National Watercolor Society show back in '81, is #2 in a series. I did about nine or ten of them, a series of that exact drawing but different paintings. I varied colors and I also used different scenes of rocks and buildings and lakes and boats in the background instead of just Chinese mountains with a little foliage on them. It was a very popular series. That's the only one I've got left. One of them was bought while I was still painting it.

I also did a lotus series, a haiku series, a doodle series, and several others.

GEORGE WEST: You've said you try to avoid repeating yourself in your work. What's the difference between forty studies of one motif and repeating yourself?

HS: Just repeating yourself is doing the same thing over and over again. Forty studies of one subject is like variations on a theme in music. Look at Rachmaninoff's *Variations on a Theme by Paganini*. Very gorgeous. He did about thirty variations on that one group of five or ten notes. Now that's a series. That's what my series of lotuses was intended to be. I try not to just repeat myself. Rather, I try variations on a theme.

JUNE FREEMAN (AN ARTS WRITER): Howard always has had an interest in educating himself. He was practicing "lifelong learning" long before that became a popular phrase. He's never finished his education.

EDWIN BREWER: In 1981 Howard earned Signature Member status, a significant achievement. You have to be accepted in five of MidSouthern's annual juried exhibitions. Only seventy members out of seven hundred in MSW's twenty-five years have attained this distinction.

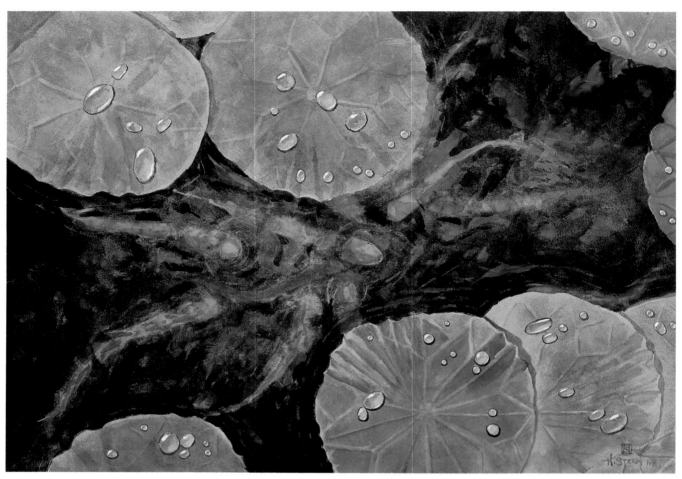

Surface Feeders (c. 1978)
Watercolor on paper, 22 x 30 inches

Photograph by Cindy Momchilov

HS: That's one from the water drop series. I knew I had it right when everybody wanted to know how I did it. One of the paintings from this series won the Kunz Purchase Prize at the San Diego Watercolor Society International Exhibition.

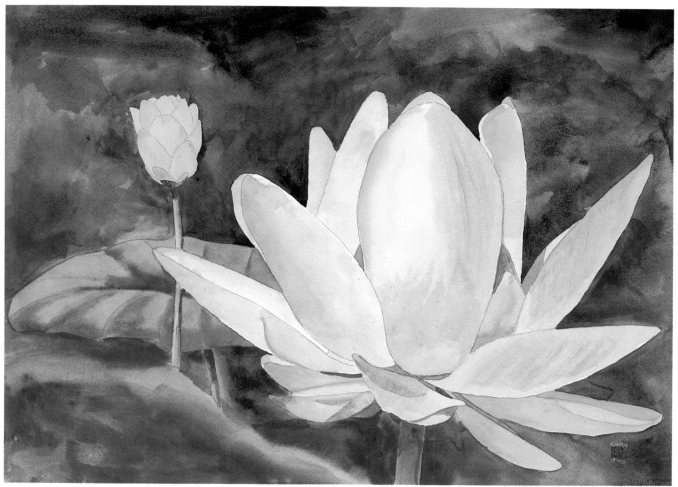

Lotus Flower (c. 1980)

Watercolor on paper, 22 x 30 inches

Photograph by Cindy Momchilov

HS: This is one from my lotus series.

Gift of the Rain (1968)
35mm color slide

Winter Fruit (1979)
35mm color slide

Color Photography: *Open Your Eyes and See*, c. 1965 - 1983

Meanwhile, Howard was working on a specific photographic project—a color slide show called *Open Your Eyes and See*. Along with "dew drops on lily pads," this show came to epitomize Howard's artistry to many people in the community.

CAROL MORRIS: I loved his photographs. I remember pictures of things like a crack in a wall, a gumball, a bird in a tree; he saw pictures that others just didn't see.

CHARLES FOGLE (AN ARTIST): Howard always pays close attention to detail. He's especially conscious of light and lighting. I can call to mind a painting of a dew drop on a lily pad....

FRED COLEMAN: He was like that—you know, like the time he hit the brakes when he saw that field full of spider webs. He could see pictures that others wouldn't see.

CAROL MORRIS: I remember there was one photograph I questioned. It was a broken window on a car. I asked Dr. Stern why he had taken a picture of that. "What do you see in that?" I asked. "What do I see?!" he said. "Look at the sun shining on that broken glass and all those colors. To me, that's a beautiful prism." To me it looked just like a broken window. Then he made a painting of it and I could see it differently.

VIRGINIA STERN: He was quite observant. In fact, that's one of the things he would always tell me: if you just keep looking, you can see a picture.

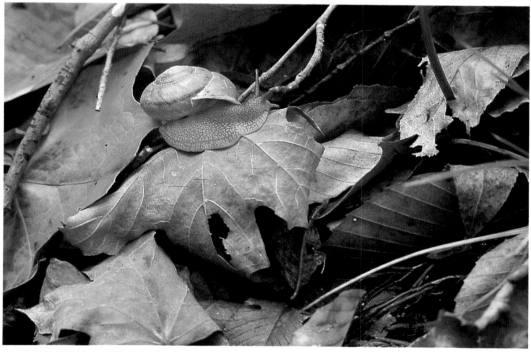

Untitled [land snail] (1967)
33mm color slide

HS: We saw this guy out in the woods near Blanchard Caverns.

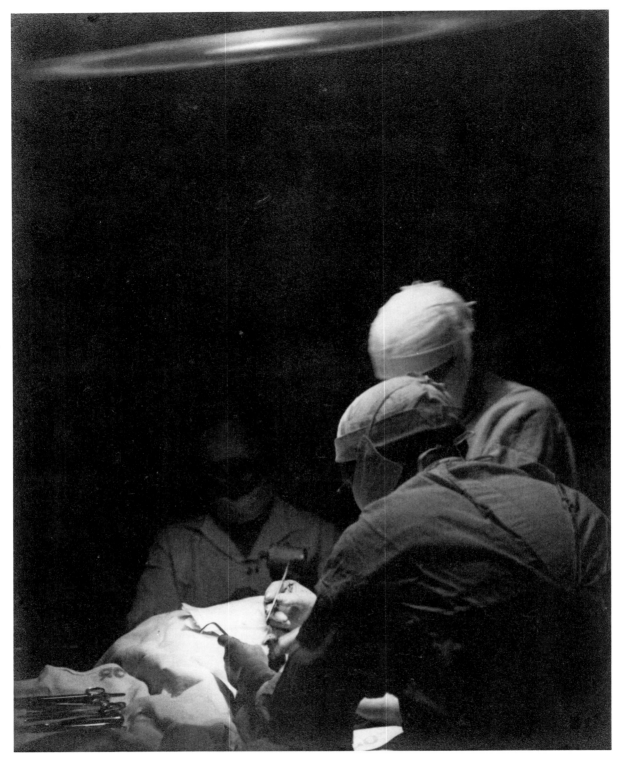

No Act So Near to God (1937)
Gelatin silver print, 9 3/8 x 7 1/4 inches

HS: Surgery is an art. It's an art to be able to do the things you have to do without damaging the patient. You have to injure him some just to cut your way in, but to do the job without adding any more insult to the injury is an art. I took a great deal of pride in that.

GW: Did you ever have to invent or improvise?

HS: Most of the improvising I had to do was in skin grafting. When you get a bad burn and there's not enough skin to cover it you have to figure out how to make it cover. I devised a way to do it that worked. Do you know about this business of stretch steel where they take a sheet of steel, make alternating slits down it and then pull it apart? I did that with the skin graft. It was a little burned kid and I was able to cover him up with it.

Many's the night I went home from the emergency room and cried myself to sleep. It was rough. I hated it. Art was a good escape. I could get away from it through painting.

Retirement from Medicine: 1980

In the final years of his medical practice there was increasing tension between career and calling, but in 1980 Howard reached his long-awaited retirement from medicine.

HS: I was a good doctor. I leaned over backwards to be extra good, which I was, so that I never really hurt anybody. Finally, at age seventy, I was able to retire. Thank God.

CAROL MORRIS: I was nursing in surgery when I met Dr. Stern. He had one of the best bedside manners; he could always put a patient at ease. He was just one of a kind.

ANNA MAE GARDNER: Dr. Stern is a very caring man. He always was more interested in life and people than he was in making money. Many times at Christmas—now this was before welfare—I saw him send out letters to patients who owed money but were on hard times, canceling their outstanding bills. He always said he didn't want to be the richest corpse in the cemetery.

KNUCKLEHEAD: I think there was a growing resentment of his medical practice there at the end of his career. He had already kind of given up photography because he had to have an art he could put down in a minute if an emergency came up.

FRED COLEMAN: Like Howard always told me, he was a left bank man with a right bank job.

HS: Even though I began to make more money in my medical practice and finally made enough to retire on, I never did become dedicated.

JIMMY RHYNE: Howard was always interested in more than just medicine. It was possible to be that way in medicine when we started. When I graduated from med school in 1941 we could cure syphilis, we could cure malaria. Nothing else could we cure. The expansion of medical knowledge is just phenomenal. You take pediatrics: then, there were six journals internationally and three in the United States that were important in the field of pediatrics. Now there are over three thousand! It isn't as easy now to diverge from the field of medicine if you're going to keep up with what's going on. So the whole practice of medicine has changed. Today it's a business rather than a profession.

I don't think Howard ever got the sense of being deeply involved with every family he touched. I'm a pediatrician and you become a Dutch uncle in every family you handle, whereas you don't get that involved in a surgical specialty because you don't see patients in every sort of situation. That may be part of the reason he didn't find medicine as rewarding as many other doctors do. There are some people who eat, drink, and breathe medicine and there's not much else that interests them.

Kalahari Nocturne (1988)
Gelatin silver print, 10 7/8 x 13 3/4 inches

HS: This is my favorite of all my pictures.

GW: It's dream-like. How did you get it?

HS: We were in Etosha National Park in Nimibia at a huge dried-up lake bed—a salt pan—that had a water hole in it. There had been an eight-year drought, so the water holes were the only places where there were any animals. It was like going to the circus every day! This one was at night. The light from our settlement was reflected over there on these elephants. I hand-held my camera, backed up against a lamp post, and did about an eight or ten second timed exposure on it. I held it against the post and did about four or five shots. All of them were nice and sharp, but that one was the best of the bunch.

GW: An eight second exposure is a gymnastic feat in it's own right!

HS: I had the camera backed up against the post so it couldn't move and stayed steady. I was using an ordinary 50mm lens. That one was the prize of my whole trip. Those were wild elephants. The only thing that separated me from them was a wire fence.

Travel and Art: Since 1980

Howard's retirement gave free rein to his painting and other interests. Experiments with new techniques continued. Further travel experiences supplied more subjects for both painting and photography. In 1981 two of his paintings won prizes in national competitions. Eleven years later a retrospective exhibition of his photographs was held at the Hooks-Epstein Gallery in Houston, Texas.

ED FREEMAN: At age seventy-seven, when many men are looking for some peace and quiet, Howard invited me to go with him on a trip to Africa! After that the only two things left undone on his list were scuba diving and learning to fly. He's very adventurous and ready to take risks.

HS: The closest I ever came to flying is hang gliding. The last lesson I took was just before I went to the Galapagos in 1992. I was running to take off but the wind wasn't strong enough to take me up. My speed was just enough to lift me off the ground so that I couldn't control my feet and down I went—and clobbered my knee. So I limped all over the Galapagos.

HS: I've been to all but two continents now. In 1985 I went to Kenya and Tanzania. I went back to Africa—the Skeleton Coast—in 1988.

There's a mystique about Africa that gets in your blood. Once you've been there you can't ever forget it. When you're on the plane and heading home you're already homesick for it and want to go back. Africa's that kind of place. When you're back home you think about it all the time.

Skeleton Coast Road (1988)
Gelatin silver print, 7 3/4 x 9 3/4 inches

Yellowstone Landscape (1986)
Photograph by Cindy Momchilov
From a sketchbook
Pencil on paper, 8 x 10 1/2 inches

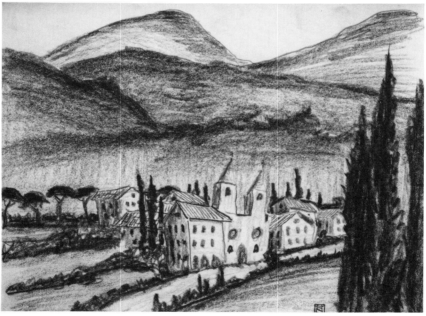

Untitled [Italy] (1983)
Photograph by Cindy Momchilov
From a sketchbook
Pencil on paper, 8 x 10 1/2 inches

HS: I started sketching again in Italy during a painting workshop in 1983. My sketching used to be pretty crude but it's gotten much more sophisticated in the last ten years. I would sketch as we rode along on our bus through the Italian countryside. Those were continued sketches. I'd see a barn out there but by the time I got through with it we'd be forty miles down the road and there would be a mountain, so I'd put it in. I got in the habit of sketching like that. When Harding and I went out west he would drive and I'd sketch.

HS: When Tom and I took my trailer out west in '84 we stopped at Petrified Forest National Park. Chris Andress, who grew up in our backyard, was the Chief Ranger there at that time so we stopped and visited with him and his wife Paula. They took us around and showed us the park. It was thrilling.

TOM HARDING: And that's when you discovered that whatever it was.

HS: *Placerias dicynodont.*

TH: I never learned how to say it. I don't know it yet.

HS: Well, I had to learn it. I found it and I'm proud of it. It was a Triassic reptile about the size of a rhinoceros. Two years later Jane and I were out there and stopped to visit with Paula and Chris again. There in the middle of the courtyard was a very large plaster of Paris object that Chris informed me was the skeleton I had discovered two years before. The University of California at Berkeley had come and dug it up, packed it in plaster, and were taking it back to the University.

CHRIS ANDRESS: I can recall the day that Howard found the bone fragment. That morning we went out—Tom Harding, Howard, and I—to a basin we called the "Dying Ground." It's part of the Chinle formation, a 200- to 230-million-year-old rock strata. I explained to them how to hunt for newly exposed fossils by following up the water courses. Dr. Stern's medical knowledge came in handy. He recognized a bone fragment that turned out to be a large piece of the skull of a *Placerias dicynodont*. It was an unusual find.

GEORGE WEST: When did you first get interested in dinosaurs?

HS: When I was about six years old. That was when they had first started finding them and giving them names. There were drawings of them in a 1916 issue of *National Geographic* that we had. When I was twelve or thirteen, I would draw them from memory in study hall.

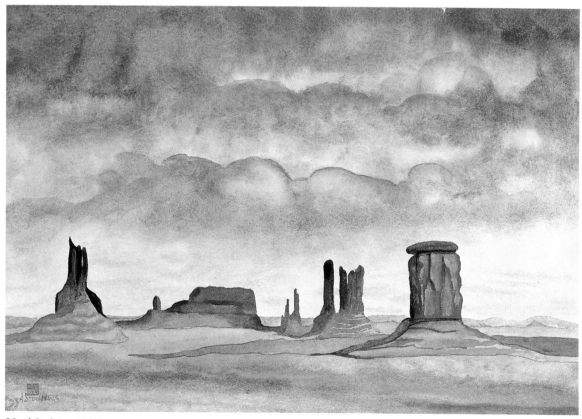

Untitled (c. 1985)
Watercolor on paper, 22 x 30 inches

Photograph by Cindy Momchilov

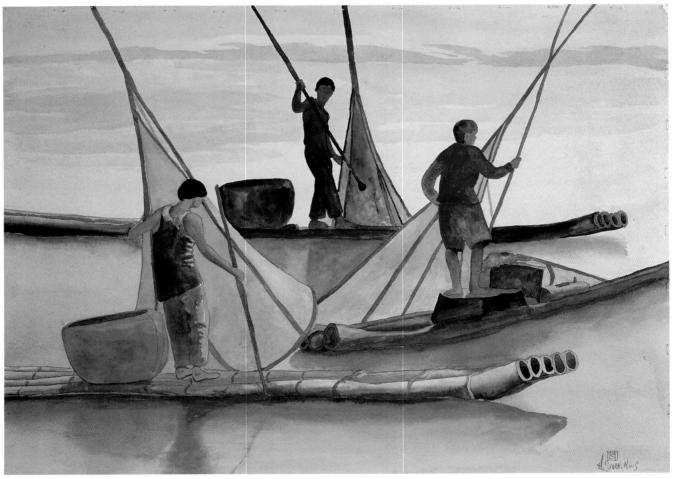

Li River Fishermen #2 (1987)
Watercolor on paper, 22 x 30 inches

Photograph by Cindy Momchilov

HS: This is China on the Li River in Kwelin. Actually, that's three slides and one mistake. The water in the background was a mistake. I washed it off and that's the stain that was left. So the stain says to me, "Look, I'm the river early in the morning

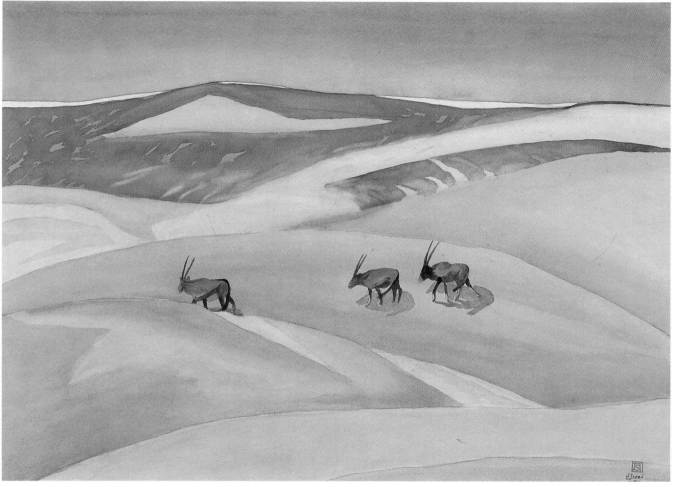

Namib (1988)
Watercolor on paper, 22 x 30 inches

Photograph by Cindy Momchilov

HS: This is one of the last paintings I've done. After I painted it I didn't think it worked quite right so I painted in the oryx. Now I really like it. I hung it in my bedroom so that when I wake up in the morning I can lie there and look at it. Of course, the memory of the place has a lot to do with it. That's my favorite desert. It has a mood of infinite space, curves, exotic animals. And not far from there is the Atlantic Ocean. If I knew definitely the moment I was going to die I'd go back there and head out into the desert so I could die out there in the middle of it. That's the kind of effect it had on me.

Confluence 1 (1977)
Watercolor on paper, 22 x 30 inches

HS: This is one of my doodles. Jason Williamson had run out of material on the last day of one of his workshops, so he showed us this technique. You throw a bunch of color at the paper. Then turn the hose on it, wash it off, and it leaves a stain. Then you do it again and again until you have a bunch of stains. After it dries you outline every change in value and hue in India ink. Then pick out accents with gouache. It starts out being totally right brain; then the left brain comes in when you start picking out the accents. It's like the world coming out of chaos—a sort of reverse entropy.

Changing Style and Vision: 1930 - 1990

HS: Part of the gobbledy gook about painting is when they say, "You have made a statement." Maybe I have, I don't know. But I don't know about "statements;" I know the subject and I made a nice picture. That's all I care about.

As far as I'm concerned, I'm not trying to divide my paintings into phases. I just paint what I like. Each painting tells me how it would like to be painted. I don't care if it's totally non-objective or realistic, I'll paint them side by side.

I don't have a special style. I do everything as it strikes my fancy. You can't look at four or five of my pictures and say "That's Howard Stern's work" because there are no two alike. I don't follow any formula. That is, I don't do extensive series of things. My formula is the whole world and everything beautiful in it.

GEORGE WEST: Your approach to your earlier paintings is markedly different from your more recent work.

HS: It's not until now that I realize they are right brain paintings. I didn't realize I could paint with my right brain. I always thought I was too inhibited and too controlled. I learned to draw with a T-square and triangle. I've spent fifty or sixty years trying to get rid of that damn T-square and triangle attitude.

HS: Oil painting is such a left side of the brain thing. Watercolor uses the right side—just let it go. I found that oil painting was a lot more difficult than watercolor. You have to work to make the oils do what you want them to do; but the watercolor—you just stand back and it'll do it for you. You can have happy accidents with watercolor.

GW: Do you place more value on a work that was hard to do than on one that was easier?

HS: No, not necessarily. I take stock only in the finished product. If it's easy, that's good. If it's hard, that's alright, too, as long as I get the finished product I want.

I've had people tell me that some of the best paintings they did were the easiest ones because they came from the right side of the brain and wam, bang, thank you, m'am, the painting's done. It doesn't happen that way for me very often. I have to work on them.

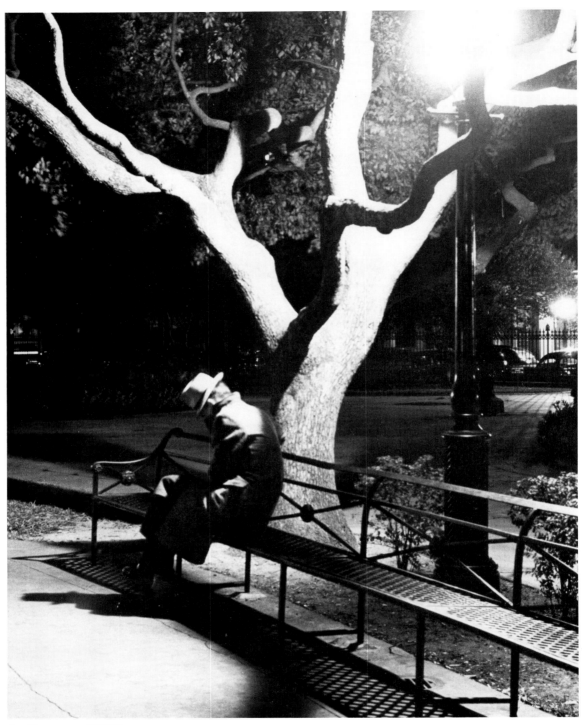

Le Penseure (1939)
Gelatin silver print, 13 1/2 x 10 1/2 inches

HS: Just recently I've recognized that some of my old negatives are worth printing. I was going through some old prints the other day and saw one that made me wonder why I hadn't enlarged it. I have lots of negatives that I never printed, which I've looked over later and liked.

You know my photograph, *Le Penseure*, the guy sitting in Audubon Park with the streetlight over his head? When I took that one in 1939 I had high hopes for it, but when I got the negative I said, "Oh, hell, this is soot and whitewash." That means the black is murky and the white isn't bright. So I put it away. I didn't take it out and print it until 1988 or so.

GW: That's almost fifty years of incubation time.

HS: Your tastes change, you know, and I think my tastes have matured over the past fifty or sixty years. I can see a lot of stuff that I wouldn't even have looked at in the old days. Now I jump at it.

GW: I'm intrigued by how you've moved from one medium to another. What has prompted so many changes?

HS: That, again, is more competitiveness.

GW: In painting or in photography, who are you competing with?

HS: I'm competing with me and every artist since time began. My prizes are good pictures.

GW: How did the desire to compete influence your photography?

HS: It had to do with the quality of work I did. I would put out top quality to win competitions.

CHARLES FOGLE: Sure Howard is a competitive artist but I see that as part of his nature. Have you ever known a highly productive person who didn't have a strong ego?

LOUIS FREUND (A PAINTER): Howard is competitive. He was always elated when he won a prize and he would be content—for a while. But then he would seek a new challenge to master. This is another quality I've always admired about him—he strives to excel.

Diamond Ring, Monte Alban (1991)
Gelatin silver print, 10 ³/₈ x 13 ¹/₄ inches

HS: Eleanor and I went to Oaxaca, Mexico, in 1991 to photograph the solar eclipse. It was a strange experience. I've never before or since seen anything like it. So I'm addicted to chasing eclipses now. I went looking for another one the next year down in South America.

The photograph is nice but you should have seen it throught the viewfinder on the camera! I had my camera mounted to a 1200mm lens—a 300mm lens and two converters. The sun filled up the frame and I lay there on the ground looking at it. It was all I could do to take the pictures because it was such a religious experience looking at the thing. I could see the moon—just a black disc—but I could see around it. There was a space back there you could see. The whole thing had such an impact on me. I sort of felt that if I moved my eye just a little bit and looked over there I could have seen God.

Personal Changes: 1989 - 1993

Events of the past several years have been tumultuous for Howard, leading to major life changes.

HS: My marriage to Eleanor Kempner Freed was in 1991. Back in the 1930s, when Eleanor lived in Memphis, she would come to visit in Little Rock. I would date her every time she came over and we fell in love. Eventually, about 1936, I asked her if she would wait for me to finish my internship and start my practice and so forth. I assumed that this was a proposal of marriage; apparently she did not. She told me she wanted to stay "heart whole and fancy free."

Two years later I met Jane Ellenbogen. We fell madly in love and in 1940 we were married. We had a more or less happy marriage for nearly fifty years. She died of lung cancer a few months before our fiftieth wedding anniversary.

Eleanor, meantime, had married twice. Her first marriage was a disaster ending in divorce after a year. Her second marriage, to Frank Freed, was very successful and happy and lasted about twenty years. Frank died of cancer in 1975.

In 1976 I ran into her at a funeral in Little Rock. We greeted each other enthusiastically and spent about four hours sitting and talking. During this time we found that we still cared for each other. When she went back to Houston, we corresponded and occasionally called each other on the telephone to schmoose. During Jane's illness, Eleanor was very helpful to me.

Then Jane died and I felt totally lost. For two weeks I lived alone in the house and my kids said to me, "Pop, Mom's gone and she's not coming back. You need to make a life for yourself. Why don't you go visit Eleanor." After thinking this over for four or five days, I packed up and went to Houston.

Eleanor and I lived together from 1990 until her death in 1992. I knew when I went to Houston that she had advanced far into metastatic breast cancer, but I did not know that she also had Parkinson's Disease, which was in a very early stage. The Parkinson's became worse and she became more handicapped with it. She refused to marry me on the grounds that I had already lost one wife to cancer and she wasn't going to be the second. Finally about September of '91, she was put on a new protocol of chemotherapy for her cancer. When she asked how long the treatments would last they said about two years. She immediately brightened up and turned to me and said, "Well, if I'm going to live two more years, I'll marry you." So we booked a cruise to the Spice Islands. We flew to Singapore where we boarded a cruise ship that sailed around the Indian Ocean to Bali

Howard and Eleanor (1990) Photograph by Alan Jay Kaufman

and back up to Singapore. We were married on board ship in the Indian Ocean off Malaysia.

Our marriage was very happy but it only lasted seven months until her death. Afterwards I promised our friends in Houston that I'd give Houston a fair chance; but after six months I wasn't very happy there. So in January of 1993 I moved back to Arkansas and here I am.

The Future—What Next?

The walls of Howard's house in Little Rock are jammed with his own paintings and photographs as well as with the work of many others, including numerous artist friends and teachers. His machine shop, dark room, photo backdrop, and painting equipment are all there. And Howard is looking again—for new technical skills, for new subjects, for the next challenge:

George West: What will come next?

HS: I'll probably start back painting an altogether different genre than before. In fact, I want to get started with doing some surrealism. Eleanor got me interested in it. I've got some good ideas. If they work out like I have them in my head they'll be some nice paintings....

A problem is getting past the "Can't Hardlys." I can't hardly care enough to develop the negatives or make a print or start a painting. That means I'm still in a burnout period but it'll disappear—if I live long enough—and I'll get just as interested as I was....

When I work at something I work so hard that I burn out. It takes anywhere from two to ten or fifteen years to burn out. I burned out on watercolor and then got started again in 1974. I burned out again in 1989 about the time Jane died. Now I'm coming back into it again. I've done the same thing with photography....

I think my burnout's about over. Tom Harding has been teaching me platinum printing and I'm really eager to put a large part of my portfolio on platinum. It's such a beautiful medium. There's a gallery in Santa Fe that sells nothing but platinum prints. They asked me to print up a batch and send them....

HS: I was once a member of the Royal Photographic Society of Great Britain. I wrote them last year and asked about getting back in. They said they'd be happy to have me but I'd have to go through being an Associate again before becoming a Fellow. The Fellowship is the top ranking membership grade. Fellowship is all I'm interested in. I might go ahead.

GW: So the competitive challenge still motivates you?

HS: I sent them the catalog from my exhibition in Houston. They liked it and asked if they could keep it for their library, so I think I could get my Associateship back on that basis and then go after the Fellowship.

GW: Speaking of competitive challenges, some of my students were disappointed that their videos were not voted the best by their classmates. They decided it was just a popularity contest.

HS: I can understand that. But it's not a popularity contest. It's just that you can't always win. And the loser isn't necessarily a *loser;* he just doesn't happen to be the one that came out on top.

Tell them that there's really no such thing as success. The painter Ed Whitney expressed it well when he said, "Success is a bitch goddess." When you succeed there's no place else to go. You don't learn from succeeding. But you can always learn from failing. Failing is a learning experience, that's all. It's not a real failure.

Tell your students that the only losers are the ones who quit or didn't try. There's no such thing as failure. There's only experience.

Quetzalcoatl (1937)
Gelatin silver print, 7 1/2 x 9 3/8 inches

Quetzalcoatl (1951)
Watercolor on paper, 17 1/2 x 14 3/4 inches

Huitzlipotchli (1955)
Oil on canvas board, 30 x 25 1/2 inches

Photograph by Cindy Momchilov

Untitled (c. 1978)
Watercolor on paper, 19 1/4 x 26 3/8 inches

Photograph by Cindy Momchilov

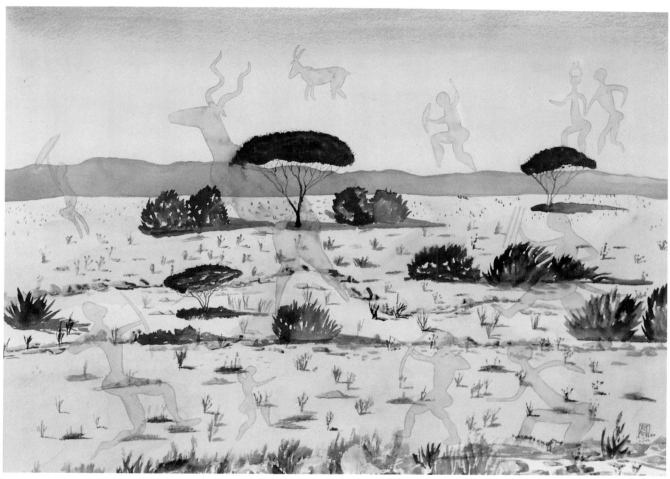

Ghosts of the Kalahari (1988)

Photograph by Cindy Momchilov

Mesas (1978)
Watercolor on paper, 22 x 30 inches

Photograph by Cindy Momchilov

Mt. Loboque, Kenya (1986)
Watercolor on paper, 22 x 30 inches

Photograph by Cindy Momchilov

Louisburg Square (1967)
Gelatin silver print, 13 1/2 x 10 3/4 inches

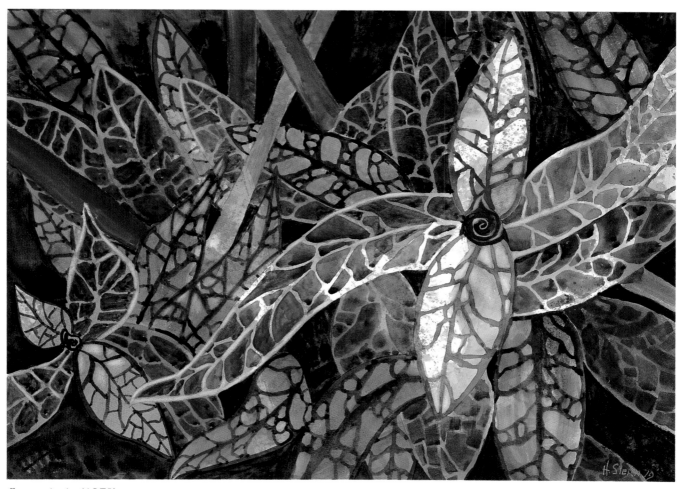

Sansevieria (1979)
Watercolor on paper, 22 x 30 inches

Photograph by Cindy Momchilov

The Ring (1981)
Watercolor on paper, 22 x 30 inches

Photograph by Cindy Momchilov

Tie Stack (c. 1985)
Watercolor on paper, 21 ¹/₄ x 30 inches

Photograph by Cindy Momchilov

Esquisse for a Bronze Door (1978)
Watercolor on paper, 22 x 30 inches
(Collection of the Arts & Science Center for Southeast Arkansas, Pine Bluff)

Photograph by Cindy Momchilov

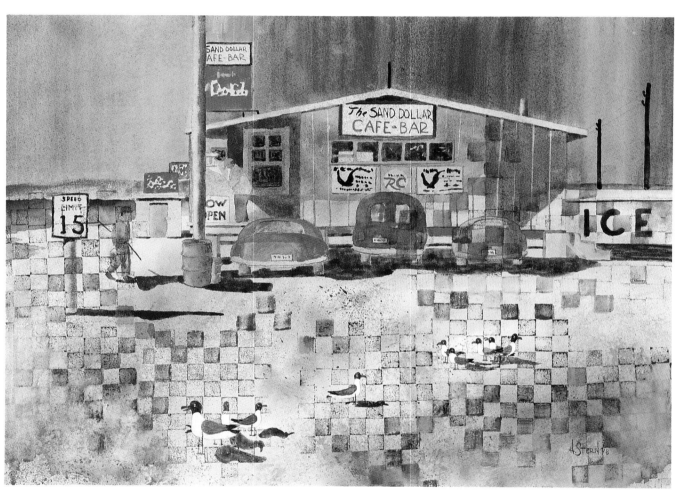

The Sand Dollar—Corpus Christie (1978)
Watercolor on paper, 22 x 30 inches

Photograph by Cindy Momchilov

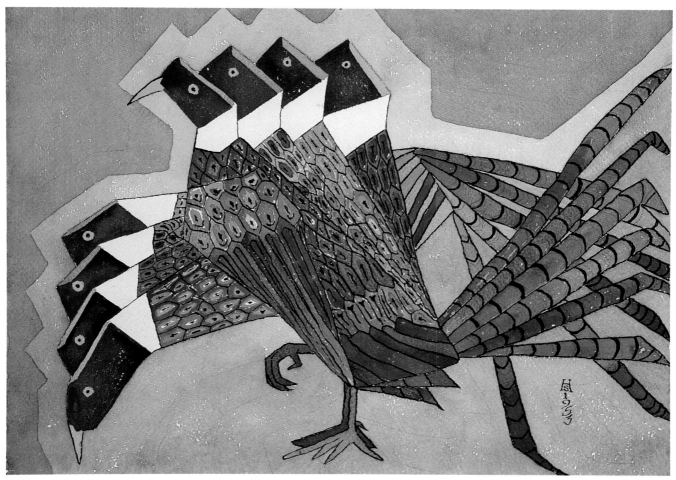

Pheasant (1953)
Watercolor on paper, 15 x 20 inches

Photograph by Cindy Momchilov

HS: This is a snapshot of my first "table-top." I made it about 1929 with radio busbar wire and corks.

Wooing of Winifred (1938)
Gelatin silver print, 7 1/4 x 9 1/2 inches

HS: This was a "table-top" I made with pipe cleaners, doilies, and some white paper I rolled up to make the columns. It was pure design and a fun thing to make.

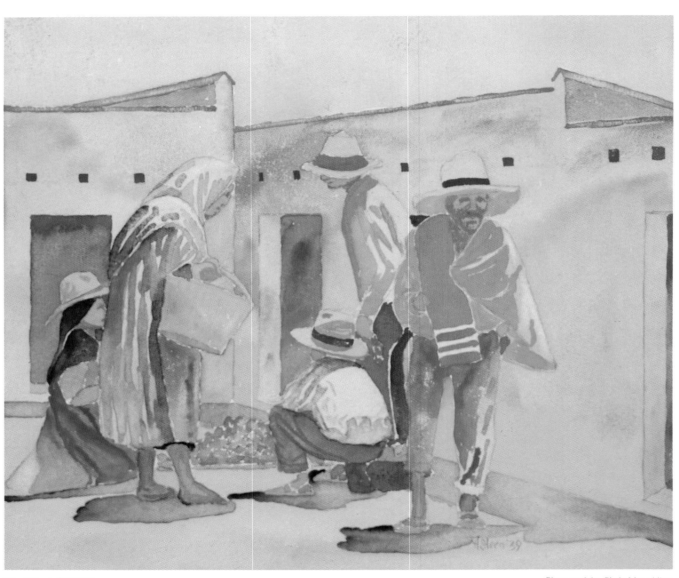

Untitled (1939)
Watercolor on paper, 13 1/8 x 13 3/4 inches

Photograph by Cindy Momchilov

Untitled (c. 1930)
Watercolor on paper, 14 x 15 ¼ inches

Photograph by Cindy Momchilov

Untitled (1954)
Watercolor on paper, 14 ³/₄ x 20 ¹/₂ inches

Photograph by Cindy Momchilov

Untitled (c. 1952)
Watercolor on paper, 15 x 20 ¹/₈ inches

Photograph by Cindy Momchilov

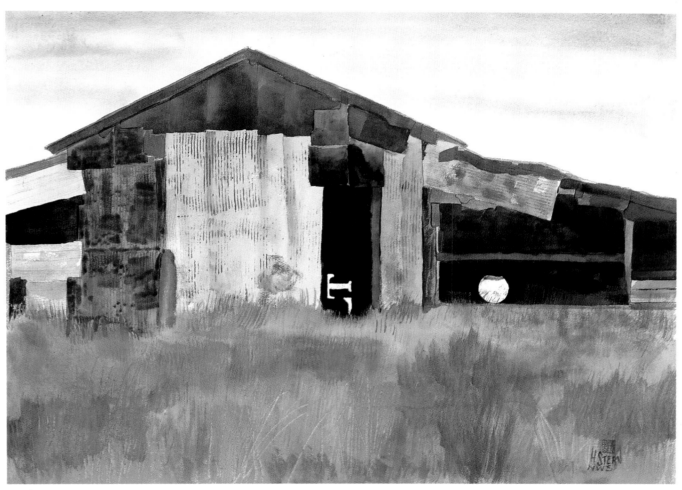

Untitled (1969)
Watercolor on paper, 22 x 30 inches

Photograph by Cindy Momchilov

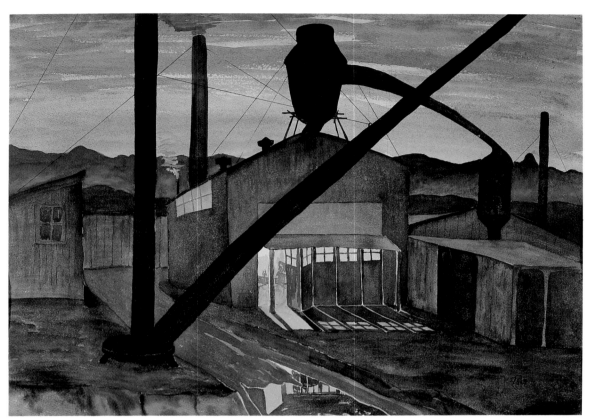

Graveyard Shift (1954)
Photograph by Cindy Momchilov
Watercolor on paper, 22 7/8 x 30 3/4 inches
(Arkansas Art Center Foundation Collection, Gift of Arkansas Power & Light, 1959)

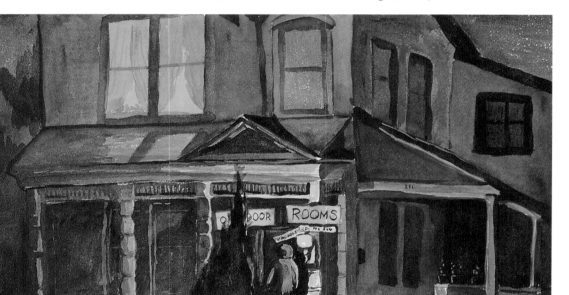

Mrs. Hardy's (1952)
Photograph by Cindy Momchilov
Watercolor on paper, 14 7/8 x 20 7/8 inches

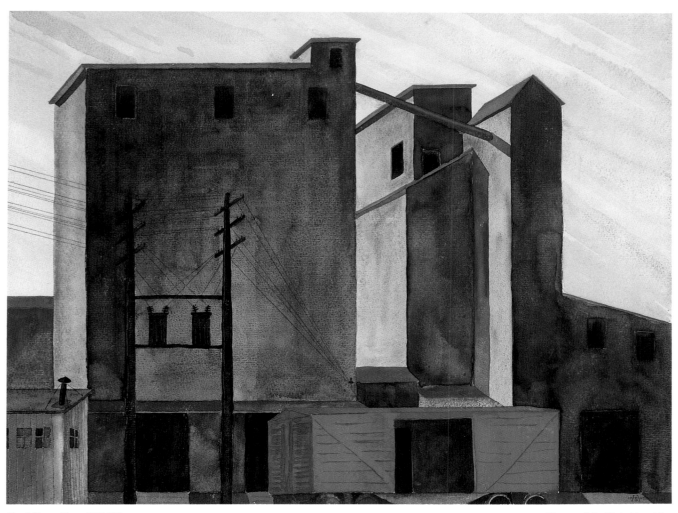

Red Box Car (1947)
Watercolor on paper, 22 x 29 ¹/₂ inches

Photograph by Cindy Momchilov

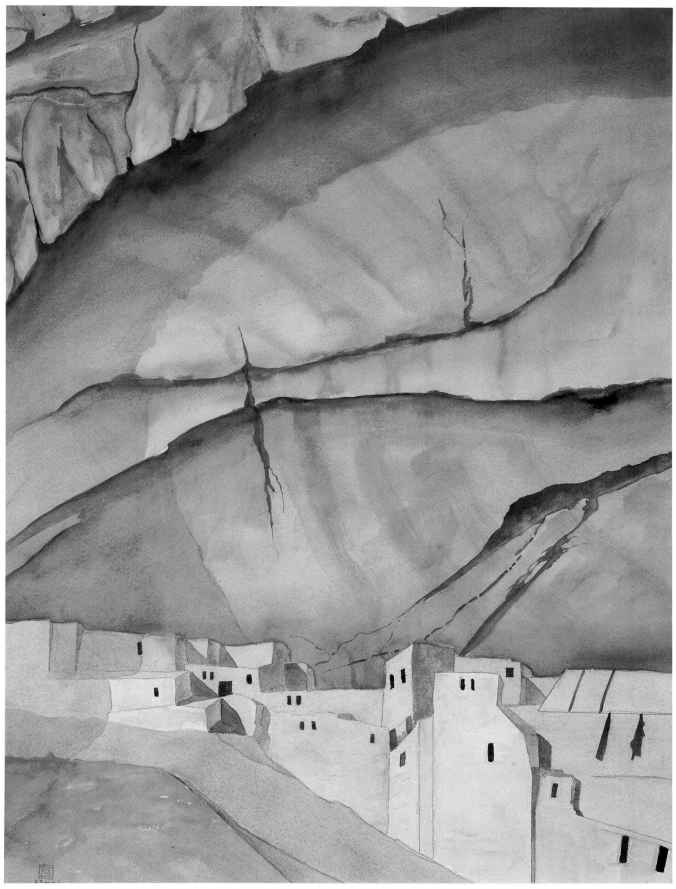

Betatakin (1977)
Watercolor on paper, 30 x 22 inches

Photograph by Cindy Momchilov

COLLECTIONS

PUBLIC COLLECTIONS:

Arkansas Department of Education, Little Rock, Arkansas

University of Arkansas at Pine Bluff, Arkansas

Ouachita Baptist University, Arkadelphia, Arkansas

Arkansas Arts Center, Little Rock, Arkansas

Arts & Science Center for Southeast Arkansas, Pine Bluff, Arkansas

Museum of Fine Arts, Houston, Texas

CORPORATE COLLECTIONS:

First National Bank of El Dorado, El Dorado, Arkansas

Worthen National Bank of Pine Bluff, Pine Bluff, Arkansas

Triad Group Limited, New York, New York

Peerless Engraving Company, Little Rock, Arkansas